IMAGES
of America

LEHIGHTON

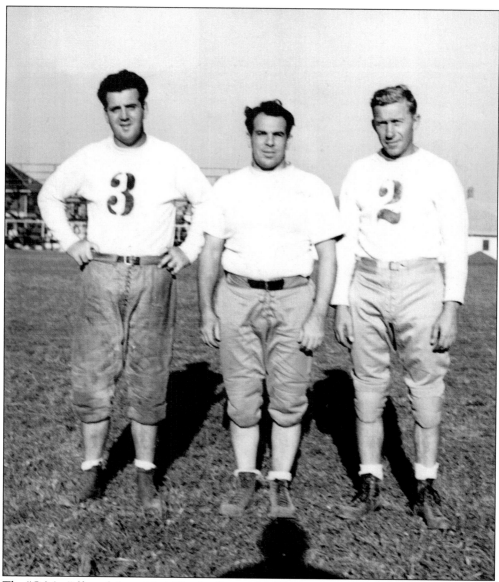

The "G-Men" (from left to right) Charles Gernerd, Al Domenico, and Louis Ginder, shown here in 1936 during their glory days, were dedicated coaches of the Lehighton Indians football team. The excellence of head coach Ginder, along with the dedication of his assistants, raised the bar for successive Indians coaches. Since then, Lehighton High School has had coaches such as George Bibighaus, Jim Wentz, Dave Parsons, Bill Brong, Lamont "Mike" Ebbert, and sons George and the late Greg Ebbert who have created their own legends. (Courtesy of Lamont Ebbert.)

ON THE COVER: Mack Trucks Inc. had this slogan in the early 1900s: "The first Mack was a bus and the first bus was a Mack." The Mack brothers opened their first bus manufacturing plant in 1905 and had orders for buses from all over the country. George Arner, shown here with his Mack bus, started his transportation company in Lehighton in 1920. Arner paid $7,000 for the bus. He ran his bus company for three years, after which he sold it to Charles Rehrig. (Courtesy of Lamont Ebbert.)

IMAGES
of America

LEHIGHTON

Lamont Ebbert and Gordon B. Ripkey

ARCADIA
PUBLISHING

Published by Arcadia Publishing
Charleston, South Carolina

Printed in the United States of America

Library of Congress Control Number: 2013931872

For all general information, please contact Arcadia Publishing:
Telephone 843-853-2070
Fax 843-853-0044
E-mail sales@arcadiapublishing.com
For customer service and orders:
Toll-Free 1-888-313-2665

Visit us on the Internet at www.arcadiapublishing.com

*This book is respectfully dedicated to the memory of
our son, Gregory Ebbert, and also for those whose loss
was the greatest—those who never knew him.*

—Mr. and Mrs. Lamont Ebbert

*Dedicated to the memory of Russell F. Ripkey.
He had a great love for the history of Carbon County
and amassed a large library on the subject.*

—Mr. and Mrs. Gordon B. Ripkey

CONTENTS

ACKNOWLEDGMENTS

The photographs contained in this book came from a large number of people who have a desire to preserve and promote the bountiful history of this area for future generations. We heartily thank all of those who generously contributed their photographs, insights, and historical knowledge that made this publication possible.

It is with a deep sense of appreciation that we pay homage and respect to our forefathers who founded and developed the borough of Lehighton and the neighboring political constituents.

Credit for this pictorial history of Lehighton must be distributed among many individuals who provided much valuable material and information relating to our community's history. Our most sincere appreciation is given to the following people and organizations who provided photographic material and supported this project: Nicole Becket (Lehighton Borough manager), Lawrence "Skip" Conarty (Lehigh Fire Company No. 1), George and Stephen Ebbert (Lehigh Fire Company No. 1), Robert Fatzinger (Walter Hammel collection), Brad Haupt (family collection), Grant Hunsicker (Warner family collection), Nicole Nothstein, Kim Snyder, Mike Tackerer, Carlos Teets, Dick Gombert, Armando Galasso, Barbara Barilla, Michelle M. Ebbert Stoudt, the George Bibighaus collection, Reuben Kunkle, Hilbert Haas, the Wilbur Warner collection, Mr. and Mrs. Gene Semanoff, Paul Smith, Susanne James (Kenneth Seaboldt collection), Robert Moser, Charlie Moser, and Lyle Stern.

Unless stated otherwise, all photographs appear courtesy of the authors, Lamont Ebbert and Gordon B. Ripkey.

We are deeply thankful to Judge John P. Lavelle and Robert Urban, *Times News* editor, for their indispensable advice. A special thanks to Rebecca Rabenold-Finsel, who provided invaluable advice and computer skills during this entire process.

Lastly, we would like to thank our wives, Joni Ripkey and Jeannie Ebbert, for their unwavering support.

INTRODUCTION

In 1746, when the Moravians established their mission in the hills that are now Lehighton, they did not realize that they were sowing the seeds of a culturally diverse and progressive town as interesting as any small cosmopolitan city. For generations, residents of Lehighton and visitors alike have been intrigued by the rich historical background left by the Moravian missionaries—a legacy that also included Col. Jacob Weiss, a Revolutionary War veteran and a man of vision.

It all began when Count Von Nicholas Zinzendorf from Herrnhut, Germany, then head of the Moravian Church, decided that this would be an excellent site for a Moravian mission, which came to be called Gnadenhutten, meaning "huts of grace." Unfortunately, during the French and Indian War (1754–1763), hostile Indians carried out a vicious raid on the flourishing settlement. When the attacking Indians left Gnadenhutten on that November evening, 11 of the Moravians were dead. Their bodies were buried in "God's Acre," located above where the mission house stood in today's Gnaden Huetten Cemetery. The spelling of Gnadenhutten changed to "Gnaden Huetten" sometime in the early 1800s. Not a trace of this ill-fated settlement remains today except God's Acre, where the remains of the victims of the massacre repose. Outrageous Indian attacks continued in the area for decades, including a brutal attack in December 1755 when the Hoeth family massacre happened in the Big Creek Valley. Three people were slaughtered and several others were captured and taken into captivity.

In January 1756, Benjamin Franklin arrived at New Gnadenhutten, today's Weissport, and had his men, members of the Pennsylvania colonial militia, construct a fort he named Fort Allen in honor of his friend Judge William Allen. The well, which was constructed inside the fort that same year, still remains at that site more than 250 years later. The fort proved to hinder attacks in Weissport, but as late as 1780, an entire family was abducted from the Gilbert farm in Mahoning Valley and forced to walk to the city of Quebec in Canada.

In 1784, Colonel Weiss visited this area and purchased 700 acres of land including that on which Weissport and part of Lehighton now stand along with the land between today's Parryville and the village of Long Run. Weiss eventually constructed his home near the site of Fort Allen. The village that developed here was first called Weiss's Mill but was later changed to Weissport after him. By 1794, all the land now part of Lehighton was owned by Colonel Weiss and William Henry, a gunsmith from Nazareth. Francis Weiss, son of Colonel Weiss, surveyed and laid out the original town plan. The future borough of Lehighton was part of Bucks County until 1752 when Northampton County was created. It remained with Northampton County until 1843 when Carbon County was established. On January 2, 1866, the borough of Lehighton was incorporated, 120 years after the mission was established at Gnaden Huetten. John Lentz, an executive of the Lehigh Valley Railroad, was selected as the first burgess.

The town as surveyed by Francis Weiss was laid out in two parts, with the dividing line being Bank Street, now First Street. There were three streets east of First Street. The second part of the town going west from First Street included Lehigh Street, now Second Street; Northampton

Street, now Third Street; and Pine Street, now Fourth Street. In this second section, Weiss and Henry located the town park, which was laid out in two parts: the western section, or upper park, and the eastern section, or lower park. This land was given to the community by Colonel Weiss a few years later in 1828. He did the same for Weissport when he donated the land for their public park. A bridge connecting Lehighton with Weissport was constructed in 1804 over the Lehigh River but the connection between the two communities began long before there was a bridge; they are true allies. The growth of both Weissport and Lehighton was slow, but the Lehigh Canal, constructed in Weissport in 1828–1829, gave the area its true start.

Railroads contributed greatly to Lehighton's growth. This became a railroad town in 1835 when the Beaver Meadows Railroad constructed a track from Beaver Meadows to Parryville. This railroad bed was later used by the Lehigh Valley Railroad (LVRR) in 1855. That same year, the LVRR was completed from Mauch Chunk to Easton, and early in the 1860s, the company established its repair yard and shops at Packerton. On March 16, 1864, the Lehigh and Susquehanna Railroad, later appropriated by the Central Railroad of New Jersey, was authorized to extend its line through Lehighton to Easton. Almost all of the railroad employees lived in Lehighton, which made this one of the most thriving communities of the Lehigh Valley. This economic success lasted until the 1960s, when almost all of the railroad operations came to an end.

Weissport is included in this book along with some of its history. But primarily because of the amount and types of photographs available, it is Weissport's history of major floods that take precedence. Owing to its low situation, Weissport has suffered severely over the years. But the people are resilient in a community where canal boats, parts of houses, personal possessions, and more can end up in their front yards.

Through this pictorial history we will introduce the people of Lehighton who lived here, grew up here, and worked in the early industries of the community. Historically, the book points out how this community was carved out of raw wilderness and how early residents built canals, railroads, factories, churches, and schools with the most primitive of tools and limited means but with the courage and industriousness of early Americans. This book will show how Lehighton evolved into the society it has become, a society built on the traditions of small-town America.

Through America's wars, beginning with the French and Indian War, the people of Lehighton and surrounding areas fought and died as did many others across the land, and we honor them here, throughout these pages, though not nearly enough considering their sacrifices.

The desire to belong to something is a trait common among human beings, and this is true for Lehighton's residents—they identify with the community and belong to it. A myriad of impressions over the years have given native Lehightonians a connection with the town that visitors can never fully have.

Our objective in this book is to reveal 260 years of Lehighton's history. In the years to come, we hope it will serve as a household reference book and a testament to the pride and heritage of the townspeople. The book is not a complete history of the Lehighton area but rather a pictorial examination of the people, businesses, and environment of the past. We have provided as many pictures as possible, though they compose just a cross-section of a rich and complex legacy.

One

A LIGHT IN THE WILDERNESS

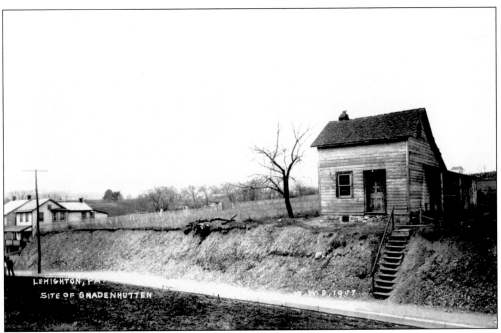

Lehighton was called Gnadenhutten by Moravian settlers in 1746. In the isolated wilderness along Mahoning Creek, they built a mission for native Indians such as the Lenni Lenape. According to the Moravian Historical Society in 1886, "In 1747 a saw and grist mill was erected on the Mahoning . . . and the first grain was ground in July the same year." Decades later, on the land of Gnadenhutten, Lehighton was founded. Its name is from the Lenapian Indian word *lechauwekink*, meaning "forks in a river," from where the Lehigh River flows into the Delaware.

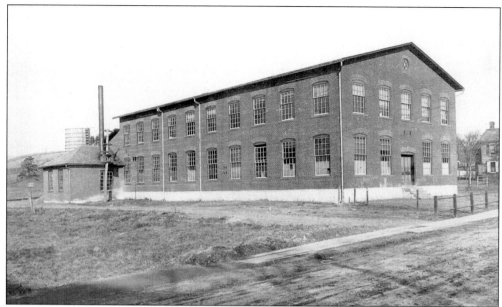

Lehighton Leather Manufacturing, known as the Gnaden Huetten tannery, was located on Bridge Street in Lehighton on the original site of the Gnadenhutten settlement. It was here where, according to the Moravian Historical Society, the dwelling houses and "a commodious chapel was built in 1749. Thus was begun this asylum for the converted Indian, as a beacon light upon the hill to guide the roving savage to the word of life . . . many a dusky heathen here professed his faith."

Count Zinzendorf, a German theologian, chose land for the mission with access to the Lehigh River for the Moravians and their enterprises. No bridge made crossing the river treacherous for the brethren. Hunting daily for game, they "contributed skins for the purchase of nails, glass and tin-cups for use at love feasts," according to the Moravian Historical Society. And there were many dangers: "We set watches and kept fires burning through the night to guard against the depredations of wolves."

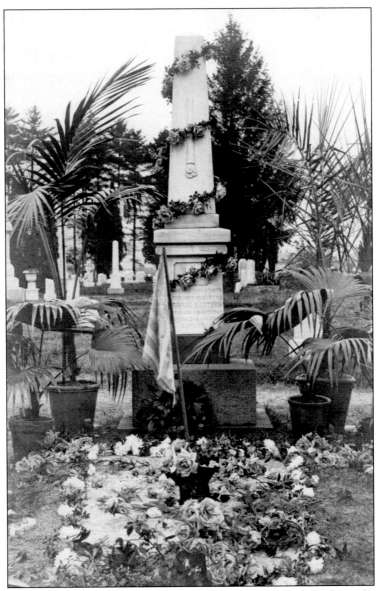

The Gnaden Huetten Memorial is located in the oldest part of the Lehighton Cemetery. The burial plot is part of the original Moravian settlement where the missionaries resided with their Indian converts. This photograph was taken at the 150th anniversary memorial service of the Gnaden Huetten Massacre in 1905. The story of this tragedy has been written about at length with some variations, but the basic story remains. This version is from the Lehigh Valley Railroad guidebook of 1897: "On November 24th, 1755 the mission house at Mahoning was attacked and burnt with eleven settlers murdered. The remains were gathered and interred together, a plain slab in the old graveyard marks the place. A few years ago a small white marble monument was also erected to their memory by a citizen of Bethlehem, also a Moravian settlement." Ten years later, Moravian leader Rev. David Zeisberger may have offered some closure for his fellow missionaries. In an entry dated July 14, 1765, he wrote, "Today intelligence reached us of the death of Minsi Jachkapoos, who had led the surprise at Gnadenhutten. He recently died of small pox at Sir William Johnson's."

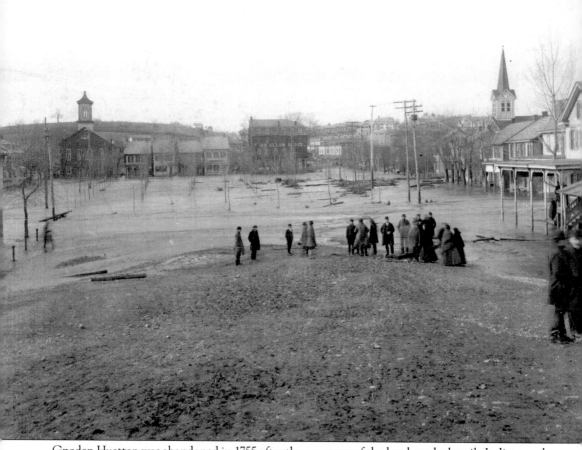

Gnaden Huetten was abandoned in 1755 after the massacre of the brethren by hostile Indians and complications of the French and Indian War. New Gnadenhutten was built across the river where Weissport is today, just a fledgling village in this photograph taken during a flood. In January 1756, Benjamin Franklin arrived with the colonial militia to construct Fort Allen, named for Judge William Allen. The well from the 1756 Fort Allen still remains at the original site. The Fort Allen building can be seen in the background between the two churches.

In 1784, Col. Jacob Weiss visited this area and purchased 700 acres of land, some from the Moravians. The land included what is today Weissport and part of Lehighton. By 1794, all the land now part of Lehighton was owned by Colonel Weiss and William Henry, a gunsmith from Nazareth. Francis Weiss, son of Colonel Weiss, surveyed and laid out the original town plan.

The town of Lehighton was laid out in two parts, with the dividing line being First Street. The second part of the town went west from First Street and included Second, Third, and Fourth Streets. In this second section, Weiss and Henry placed a town park, which was laid out in two parts as well, the western section, or upper park, and the eastern section, or lower park.

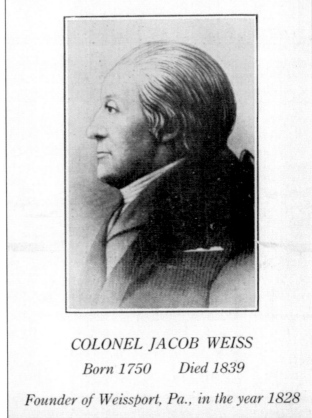

COLONEL JACOB WEISS

Born 1750 Died 1839

Founder of Weissport, Pa., in the year 1828

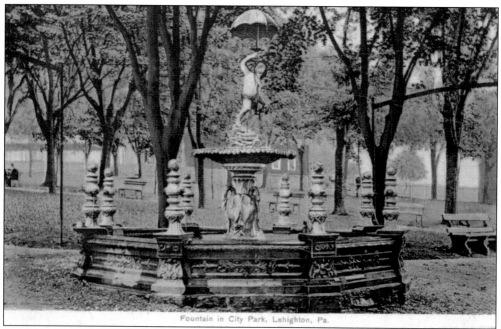

Fountain in City Park, Lehighton, Pa.

Land for two parks was given to the town of Lehighton by Colonel Weiss in 1828. The lower park has a stone fountain constructed out of natural stone in 1937, replacing the cast-iron fountain pictured. In 1982, thanks to many Lehighton residents, Lehighton's fountain was restored after being out of order for 10 years. A ceremony was held in celebration. Colonel Weiss also donated land to Weissport for its public park.

Lenni Lenape Indians who occupied what is now Lehighton spoke of a place called the "spring of healing" located between Seventh and Ninth Streets. In the mid-1800s, this land was called "Linderman's Woods" or "Linderman's Grove." On April 7, 1922, a public meeting was held to discuss purchasing the area for use by the community. On September 1, 1922, Labor Day, the newly acquired Linderman's Grove was dedicated. (Courtesy of George Bibighaus collection.)

Sometime before the massacre at Gnadenhutten, many of the Moravians and Indians moved to New Gnadenhutten at Weissport; some brethren remained at the original settlement. "In 1754 the Indians removed their dwellings to the east side of the Lehigh. Here the rich bottom lands offered better inducements to the tiller of the soil," according to the Moravian Historical Society. In January 1756, Benjamin Franklin arrived at New Gnadenhutten with the militia. The statue of Franklin pictured at right was dedicated on September 9, 1922. Franklin was honored for his important contributions to the history of this area. Contributions from the schoolchildren of Carbon County helped to pay for the monument. A social organization, the Poho Poco Tribe of Redmen, pictured below, also contributed substantially to the project. The statue still stands proudly in the Weissport Park. (Below, courtesy of Brad Haupt.)

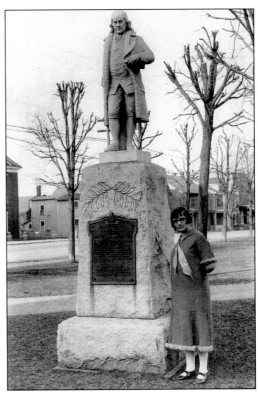

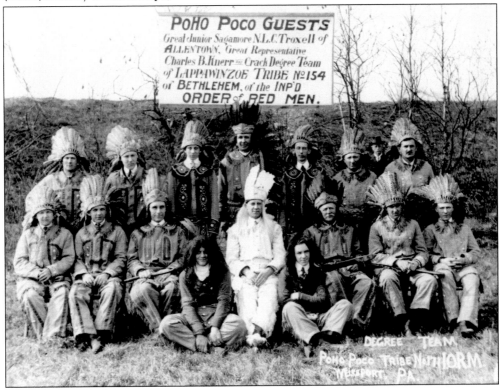

PoHo Poco Guests
Great Junior Sagamore N.L.C. Troxell of ALLENTOWN, Great Representative Charles B. Knerr ≈ Crack Degree Team of LAPPAWINZOE TRIBE № 154 of BETHLEHEM, of the INP'D ORDER of RED MEN.

DEGREE TEAM
POHO POCO TRIBE No. 171 ORM
WEISSPORT, PA.

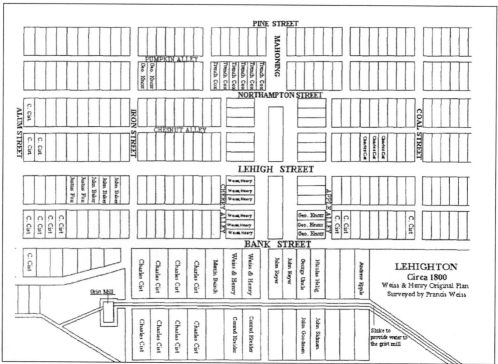

PINE STREET

MAHONING

PUMPKIN ALLEY

NORTHAMPTON STREET

ALLUM STREET

IRON STREET

COAL STREET

CHESNUT ALLEY

LEHIGH STREET

CHERRY ALLEY

APPLE ALLEY

BANK STREET

LEHIGHTON
Circa 1800
Weiss & Henry Original Plan
Surveyed by Francis Weiss

Grist Mill

Sluice to
provide water to
the grist mill

Jacob Weiss became known as an entrepreneur, which is why Philip Ginter sought counsel with him after he discovered what he thought was "stone coal" on Sharp (Mauch Chunk) Mountain. Weiss took the specimen to Philadelphia where John Nicholson, Michael Hillegas, and Charles Cist verified it as anthracite coal. In 1792, Weiss, Hillegas, and Cist formed the Lehigh Coal Mine Company, which became the historic Lehigh Coal and Navigation Company.

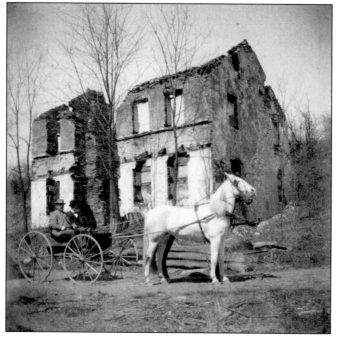

The ruins of an abandoned fort at Heilman's Dam, pictured in the 1800s, were off the beaten path in Leighton but familiar ground to Moravians and thick with Indian paths. There is no telling what bits and pieces of history went unwitnessed in this isolated place where an unknown fort was built and abandoned. A September 1882 issue of the *Carbon Advocate* reported, "Professors Bernd & Balliet captured a great blue heron at Heilman's Dam with a wing span of six feet." (Courtesy of Kenneth Seaboldt collection.)

16

Two

LECHAUWEKINK

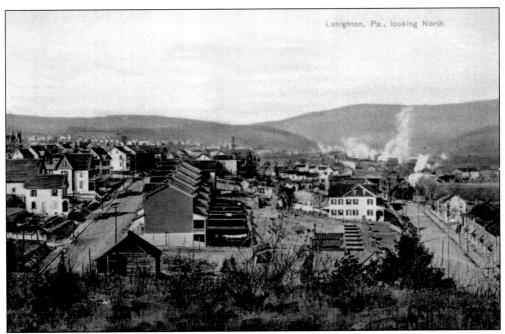

The Lehigh Valley Railroad constructed row homes on Bankway Street and South First Street, shown here in 1895. On January 13, 1922, Lehighton Borough's street commissioner, Edward Schmidt, met with officials from the Pennsylvania Department of Highways about paving Bankway Street between the Valley House Hotel and Weissport Bridge. Unfortunately, the homes on Bankway were completely destroyed by fire on March 29, 1975.

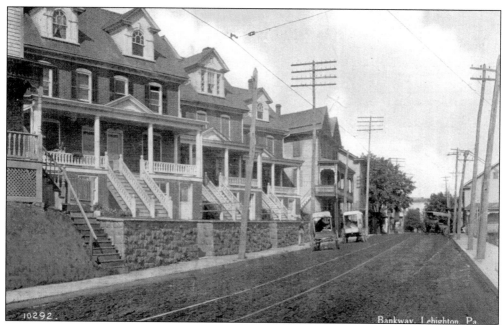

The *Lehighton Evening Leader* stated, "Bankway is surely the most miserable looking public thoroughfare in the county if not in the state, and it will be a godsend to have it put in decent and respectable condition." At a town council meeting in August 1911, a contract was awarded to John Leffler of Hazleton to pave Bankway Street with vitrified Mack brick made in West Virginia.

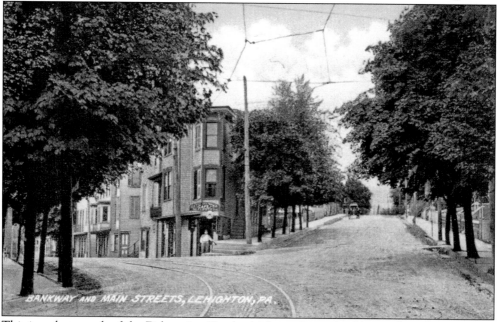

This is a photograph of the Delmonico Hotel, which was located at First and Bankway Streets. On July 13, 1904, Charles Fronheiser paid $8,000 for the hotel. On April 9, 1926, Edward Diehl purchased the establishment. Diehl came from Ashtown in Mahoning Township; he operated the hotel from 1926 to 1953. In 1953, his son Gerald "Jebber" Diehl became the owner and was proprietor of the hotel until 1960.

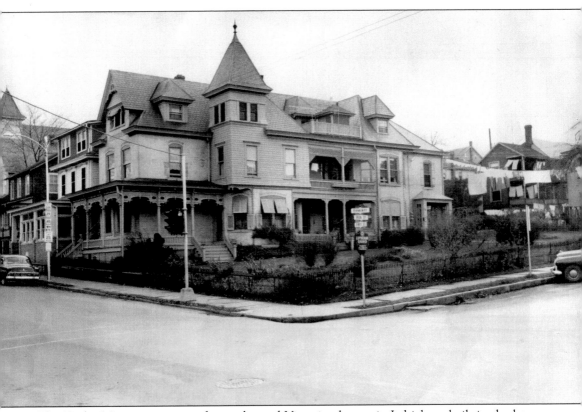

The Kistler Mansion was one of several grand Victorian homes in Lehighton built in the late 1800s. This picturesque landmark has a large corner yard fenced with iron. The photograph contains wonderful details of a time long gone. On April 16, 1956, Evan Hough of Sellersville asked permission of the Lehighton zoning board to erect a gas station on the corner of Bank (First) and Iron Street where the Kistler home was located. Five months later the building was demolished and the Bollinger and Bolts Company began construction of a Gulf service station where the Carbon Mini Mart is today. (Courtesy of Kenneth Seaboldt collection.)

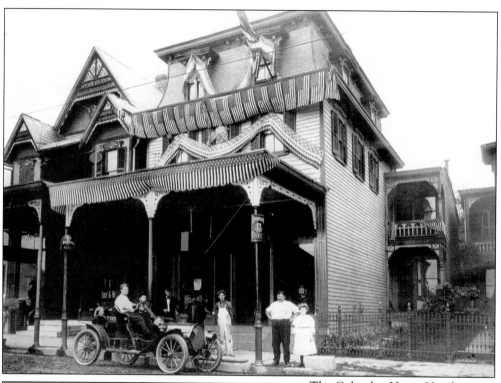

The Columbia House Hotel was located at 135 South First Street next to the former PNC Bank. In 1905, this hotel was owned by a Mrs. Miller, who paid $11,000 for the business—a great deal of money at that time. Over the years, ownership of this hotel changed many times. In the 1950s, the hotel's name was changed to Laury's Café after Dave Laury and his wife, Virginia, took ownership. Laury was a former employee of the Weissport Textile Mill. After he retired, the Lehighton bank bought the property, razed the building, and made a parking lot at the site.

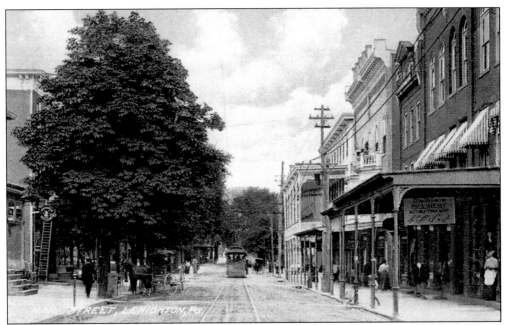

In April 1912, a local newspaper read, "Bank Street it was Mud! Mud! Mud! The mud was 6 to 10 inches deep and still 'mudding.' " As a result, Lehighton Borough purchased 1,000 tons of cinders from the Carbon Iron and Steel Company of Parryville to repair its muddy streets. This continued into June when street workers were filling in between the trolley tracks.

The Lyric Theater opened in 1909 on south First Street, across the alley from today's Alfie's Pizza Shop. Charles Schwartz was the owner, and Herbert Buck was the projectionist. Two years later the Lyric closed for repairs and had a grand reopening on Saturday, January 6, 1911; J.A. Hoffman was the proprietor at that time. Admission prices were 10¢ for adults and 5¢ for children. (Courtesy of Brad Haupt.)

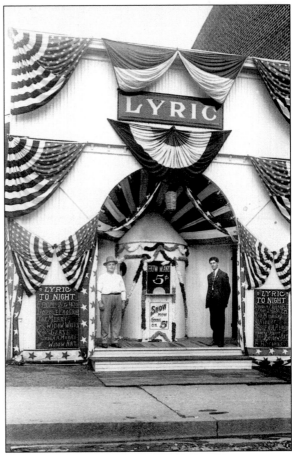

This men's haberdashery, Losos & Co., was located in "Obert's Block" on First Street. In October 1893, an advertisement by this haberdasher in the *Carbon Advocate* informed the public that, "a better and newer assortment of winter coats could be found no where else in this town or county, none shoddy." The prices of the coats were $1.50 for children, $3 for boys, and $4 for men's. (Courtesy of Brad Haupt.)

Through the efforts of various business and civic leaders in the community, a building was purchased on South First Street to be used as the Lehighton Youth Center. The building dedication took place over the Christmas holidays in December 1943. The building had cost $6,500. Frank Schultz and Frank Mazzo were in charge of fundraising. Longtime teacher and coach Lewis Ginder was in charge of building renovations.

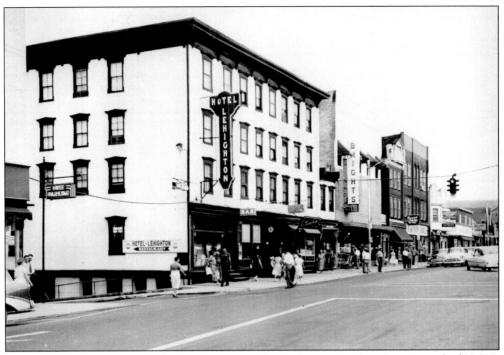

On October 31, 1924, Joseph Mandour purchased the Exchange Hotel on First Street for $32,500. At that time, he also owned hotels in Shenandoah and Milford, Pennsylvania. Mandour had the entire hotel remodeled and changed the name to the Hotel Lehighton. In 1928, William Sadallah was the hotel manager; he was followed by William Mandour and, in 1940, by George Mandour.

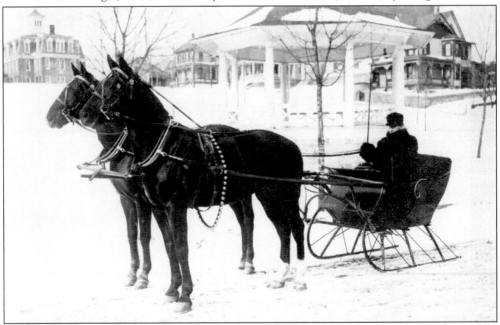

In 1875, Dr. Clinton Kistler of Mahoning Valley reported using his sled 162 days in 1874–1875, averaging 36 miles a day, with 3,672 miles traveled during the winter. Called out in all kinds of weather, the doctor had to be prepared for winter travel on slick, unplowed back roads.

In 1870, Frank Semmel owned this hardware store on First Street where the Dollar General Store is now located. In 1878, Josiah Gabel entered into a partnership with Semmel and became part owner of the business. By 1879, Semmel sold out and Gabel became sole owner. The store became known as the Gabel building until 1904, when the business was purchased by Robert Sendel and P.G. Rouse and became known as Sendel & Rouse Hall.

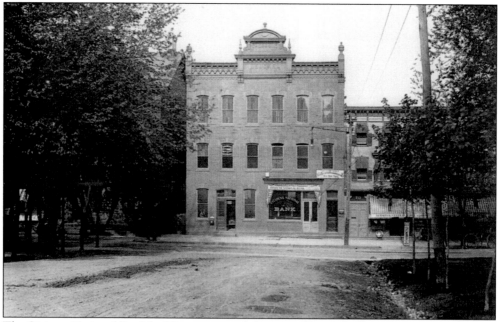

The Citizens National Bank building contained the post office and office of attorney P.M. Graul before the 1907 fire. In 1902, Graul took ownership of the *Carbon Advocate*, named one of Carbon County's most valuable newspapers, which operated until 1922. After Graul, H.V. Morthimer took over as publisher. Morthimer was responsible for starting the *Lehighton Evening Leader*. Over the years, the *Advocate* covered some of the most compelling events in Pennsylvania's history, including the railroad strike, miners' unrest, the Molly Maguires trials, and the Civil War. (Courtesy of Brad Haupt.)

Dr. C.T. Horn was born on January 21, 1848, in Mahoning Valley. He studied medicine under Dr. N.B. Reber of Lehighton before graduating from the College of Physicians and Surgeons in Baltimore, Maryland. He graduated with honors in March 1878. Dr. Horn came back to Lehighton and established an office and drugstore named the Central Drug Store, located opposite of the Lehighton Park on First Street.

On April 7, 1907, the Horn-Christman building on First Street, across from the Lehighton Park, was left in ruins by a fire that broke out at 2:30 a.m. The Central Drug Store, owned by Dr. Horn, and the home of Charles Christman were in ruins. Lehigh Fire Company No. 1 responded with its chemical engine and Lehigh Company No. 2 with its steam engine.

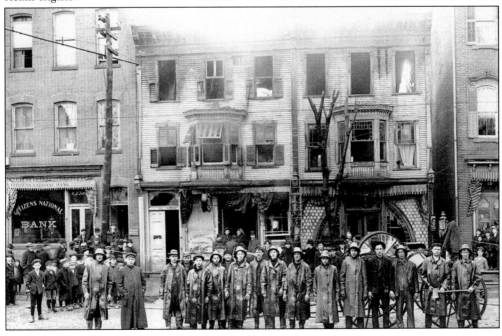

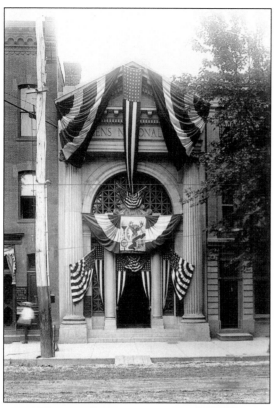

In 1909, this bank building was constructed to house the Citizens National Bank. The building was constructed on the site of the old Dr. C.T. Horn drugstore. The building, constructed in 1909, was 22 feet by 104 feet; the main room was 38 feet in height, constructed of Indiana limestone, concrete, and brick with two large columns supporting a front arch. (Courtesy of Brad Haupt.)

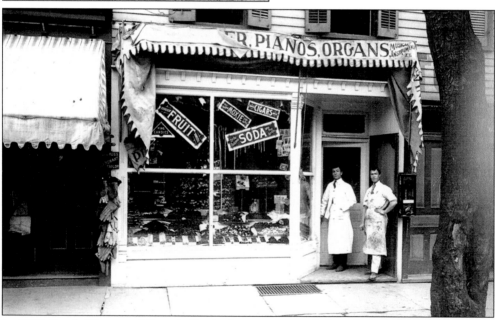

In 1900, Frank Clauss and Francis Stocker's stores were side by side on First Street. Stocker was also the proprietor of a tavern at Pleasant Corners in Mahoning Valley. At age 63, Stocker died from dropsy in his home in Mahoning Township. His funeral took place at the Lehighton cemetery. (Courtesy of Brad Haupt.)

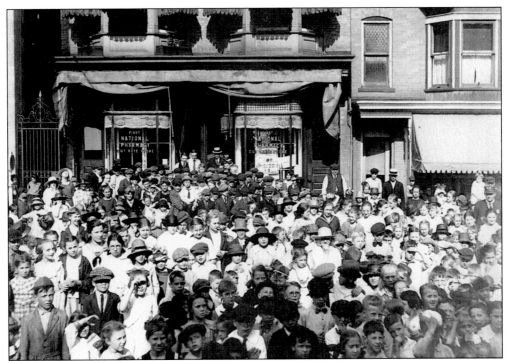

The Rauscher and Moyer Drug Store was organized in 1920 by Emanuel Rauscher of Lehighton and Lloyd R. Moyer of Sellersville. In 1935, the two men also opened drugstores in Hazleton, Weatherly, Nesquehoning, and Mauch Chunk. On October 14, 1936, the First National Pharmacy on North First Street was remodeled, and a new storefront and new lighting were added along with a new soda fountain. This crowd of local children gathered in front of the pharmacy. (Courtesy of Brad Haupt.)

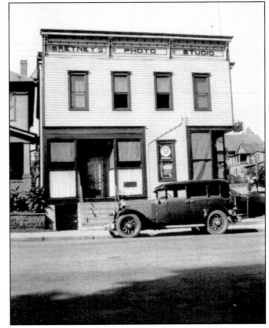

The Clement Bretney Photo Studio is pictured here in 1899. Clement Bretney opened his photography studio after working with W.D. Rishel, an early Lehighton photographer. His first studio was located on Bankway Street. In 1901, Bretney moved into a brand-new building that he had constructed on Second Street and had a very successful photography career. This building can still be found across the alley from the Lehighton Hardware store. (Courtesy of Brad Haupt.)

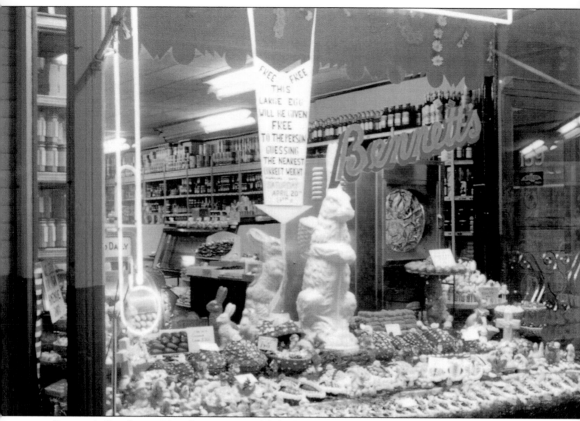

Bennett's Candies on First Street was established in 1946 when brothers Gordon and Paul Bennett bought some candy-making equipment from Harry Anderson, the proprietor of the Candyland Shop, also on First Street. One of the Bennetts' purchases was a chocolate-melting stove, and Anderson's candy maker Thomas Komas taught the Bennetts the art of candy making. The big glass window in the front of the shop, seen here, was expertly decorated with their candies all year but was especially beautiful at Christmas and Easter. The Bennett brothers thrived, specializing in high quality and finely crafted candy. Paul Bennett retired in the late 1970s. Gordon had left the candy business earlier to pursue a career in banking and founded the Bank of Lehighton.

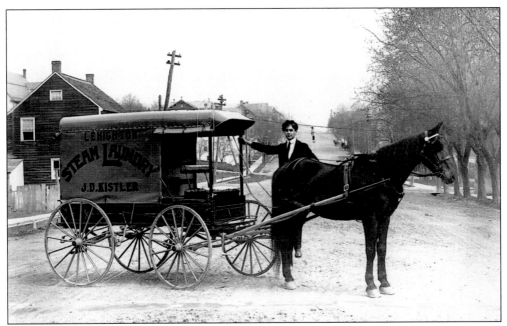

The Lehighton Steam Laundry makes deliveries on Second Street with this handsome horse-drawn wagon. A thriving business, it is listed in the book *The 11th Annual Report of the Pennsylvania Factory Inspectors for the Year 1900* as an expert in laundering. Many other local businesses are listed, such as Joseph Obert, H.H. Peters, the Lehighton Roundhouse, and the Lehigh Stove Company. (Courtesy of Brad Haupt.)

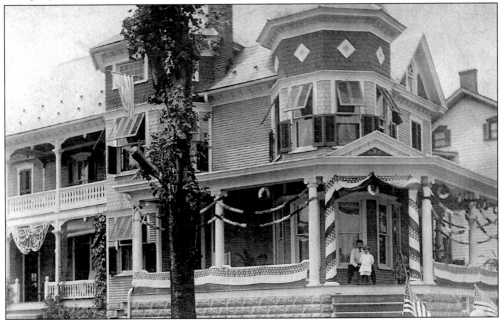

Another classic example of Victorian architecture in Lehighton is the O.W. Snyder Home, later owned by the Walter Hammel family. Victorian architecture includes features such as transoms, turrets, ample windows, gables, pediments, lintels, porticos, and mansard roofs. This unique home can still be found on South Third Street.

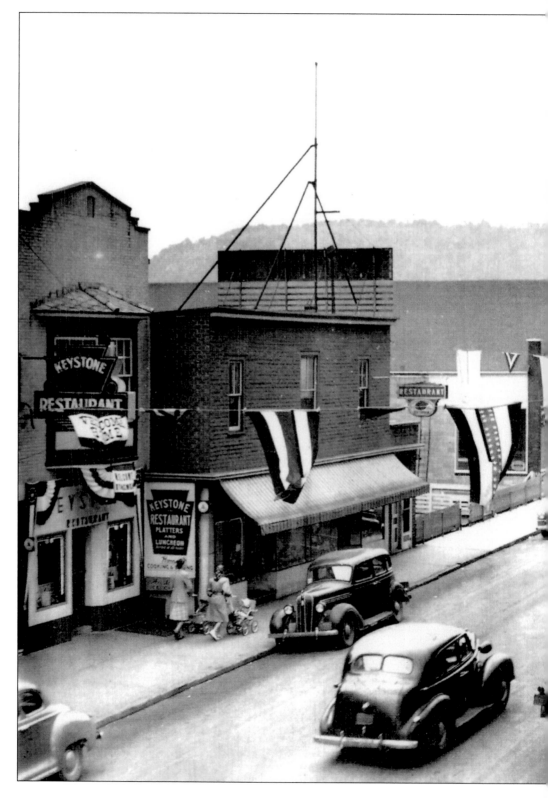

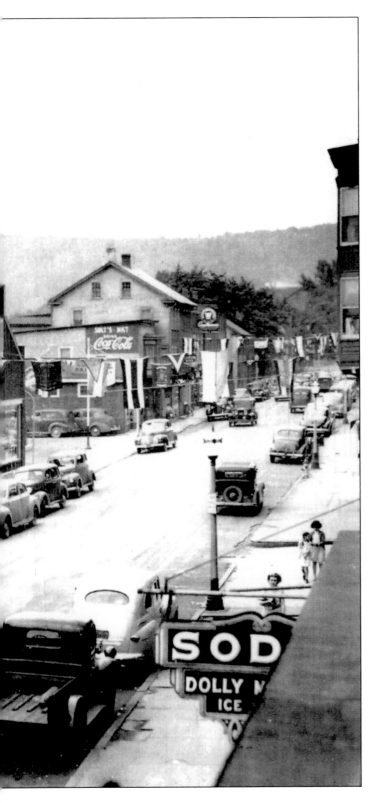

This photograph shows a festive downtown Lehighton in the 1940s. It is dressed up for a special event, perhaps a parade—note the "Welcome Home" sign above the door to the Keystone Restaurant, and the patriotic bunting. Businesses have come and gone on First Street, but some that may have been found in that era were Cohen's Department Store, Mulhearn's, Howard Seaboldt Insurance, Millers Photo Studio, Bayer's Paint Store, H.J. Dotter Jeweler, Pop Gillen United Cigar Store, Lehighton Hardware, Carl Kreuger, Presto Restaurant (which "Never Closed"), First National Pharmacy, and Harmon's Modernistic Shoe Repair Shop. (Courtesy of John L. Rheiner.)

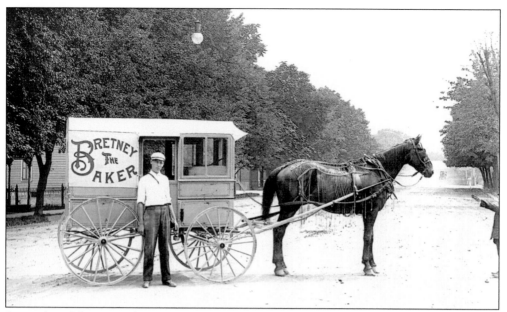

Pictured is a deliveryman for Bretney's Bakery in 1911. The bakery was owned by Thomas J. Bretney. It was located on South Second Street along with Bretney's son's photography studio. Thomas, formerly a railroader, later owned a local freight and express business in Lehighton. Clement H. Bretney, his son, was a leading photographer in Lehighton. Born in 1873, he studied photography as a private pupil under H. Parker Rolfe of Philadelphia. (Courtesy of Brad Haupt.)

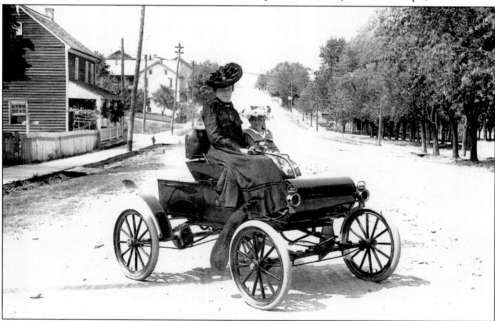

This lady and young girl are dressed in their finest as they display their horseless carriage on Second Street. This photograph was taken before the bandstand was constructed in the upper park in 1905. The lower park is heavily wooded, and so is most of north Second Street on the right. Women drivers were rare in this era, but a progressive town like Lehighton with its wide streets and friendly neighbors made driving an attainable luxury.

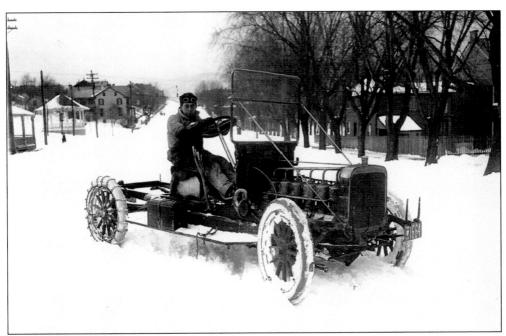

This gentleman was having fun on snow-covered Second Street—notice the chains on his rear wheels. The bandstand at the upper park is visible on the left. North Second Street was one of the best streets for sledding in Lehighton for many years. (Courtesy of Brad Haupt.)

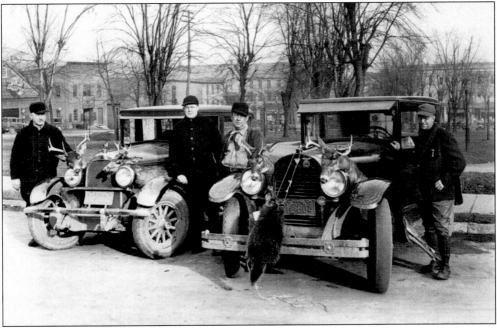

After a day of hunting in the 1920s, these sportsmen proudly display their game on North Street by the lower park. In 1925, the Pennsylvania Game Commission decided to permit farmers to hunt any deer that caused crop damage on their land. Many farmers depended on venison to feed their families in the winter. The Moravian missionaries hunted deer in the tangled woods of Lehighton to feed themselves and their Indian converts. (Courtesy of Brad Haupt.)

In 1927, Otto Kropp in Lehighton was selling Studebaker cars at the Park Garage at 110 North Street, where the post office now stands. Kropp also sold Hudson Terraplanes. The Studebaker Corporation was started in 1852 by Henry and Clement Studebaker in South Bend, Indiana. In 1933, Studebaker, heavily in debt, went bankrupt. Albert Erskine, president of the company, committed suicide later that year. Studebaker recovered and maintained operations until 1966. (Courtesy of Brad Haupt.)

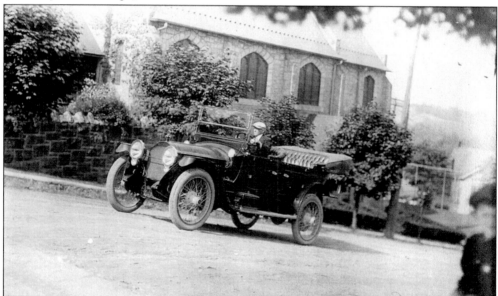

An antique car and driver brave the steep incline on Coal Street known as Hammel's Hill, with All Saints Episcopal Church in the background of this c. 1920s photograph. The nickname "Hammel's Hill" came from Hammel's Store at the bottom of the hill on First and Coal Streets.

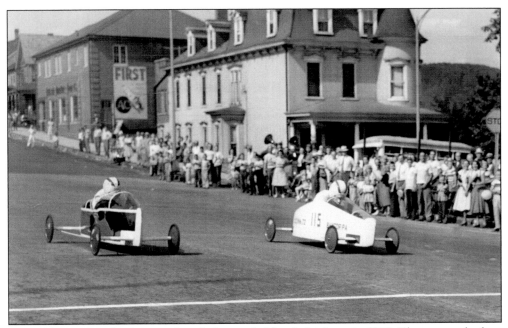

Legend has it that the first soapbox derby was held in Lehighton in 1923. The race took place after three Lehighton boys, Arland Messinger, Bryant Blank, and James Krill, decided to emulate race drivers from the Lehighton Fair. They built cars out of wooden boxes, using a crude steering mechanism of rope. A mounted Fox movie machine recorded them coming down the hill.

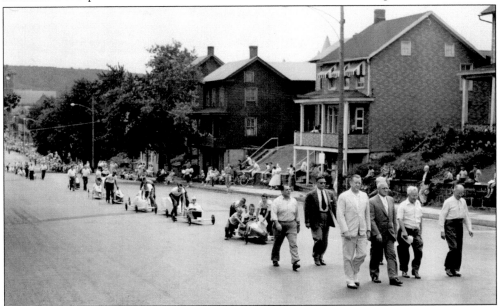

After the outbreak of World War II, coaster races, known as soapbox derbies, came to an end in Lehighton. The races were revived in 1950 by volunteers Jimmy Whitehead, Fred Neihoff, Al Domenico, Chester Solt, Oliver Smoyer, Lewis Ginder, Robert Benner, and Terrance Berger. In 1989, Glenn Finsel, Webelos leader for Cub Scout Pack 145, revived the races once again and generous Lehighton merchants donated prizes. The starting line of the Cub Scout derby was on Eighth and Iron Streets. The finish line was at Eighth and Alum Streets.

John S. Lentz became superintendent of the Packerton Shops division of the Lehigh Valley Railroad. Lentz and his family lived in this fine home at Third and Alum Streets, now the Schaeffer Funeral Home. In 1936, Wendell D. Swartz purchased the home and moved his funeral parlor to that location. A pioneer in the undertaking business, he was the first to have an automobile hearse in Carbon County, on December 24, 1918.

On December 2, 1904, a local newspaper reported that the Eugene Baer home at Third and Alum Streets was one of the "most complete, perfect residences in greater Lehighton." The building contained 17 rooms and had 100 electric lights, 50 chandeliers, electric bells, and speaking tubes connecting all rooms in the house. The house had a laundry, playroom, and three bathrooms. On the third floor was a standpipe and 25 feet of fire hose.

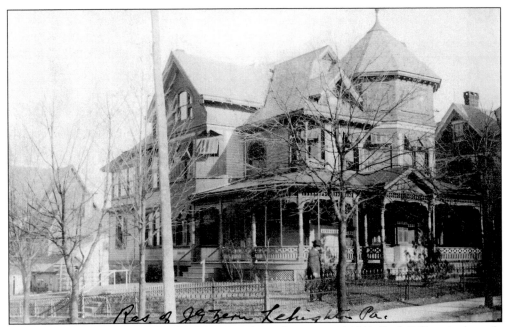

The Zern Residence on South Third Street is shown here around 1911. Dr. J.C. Zern is the only known person from Lehighton who had the honor of shaking the hand of Pres. Abraham Lincoln, in 1864. At the time, he was in his teens and obtained a position as a carpenter building hospitals around Washington, DC. It was while working there that he met the president.

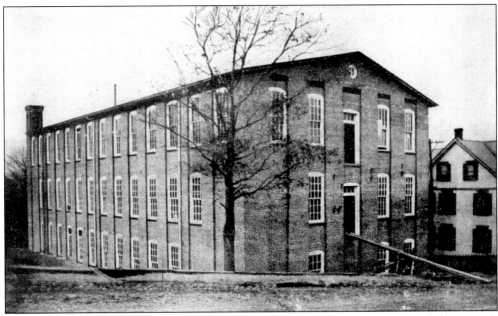

The Carbon Silk Mill on Ochre Street was leased by Scotty's Fashions Corporation of Pen Argyl, Pennsylvania. In 1957, the factory had a floor space of 15,000 square feet divided into five sewing floors, a large pressing room, a finishing floor, and a shipping department with a loading dock. In 1970, the company employed 400 people and had a $2 million payroll. For years, Scotty's Fashions was the leading garment factory in the state with five mills.

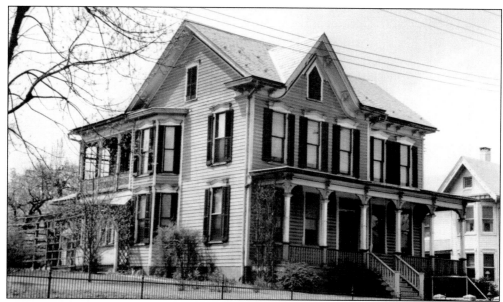

The Seaboldt home became the Lehighton Library, which was organized in 1947 by the Lions Club. The club acquired the South Third Street property for $10,600 in April of that year. The first librarian was Charlotte Berger. Board members in 1948 included Elizabeth Budihas, Ware Boynton, Mazie Ziegler, Wilmer Schoenberger, Lloyd Moyer, Wilbur Warner, Robert Jones, James Beisel, Rev. Carl Leinbach, Mrs. Wilbur Noll, William Garrett, Rev. Maurice Montgomery, and Bert D. David.

Plans to expand the library on Third Street were abandoned when Samuel Miller, president of the *Allentown Call-Chronicle*, offered land on North Street for a library in memory of David A. Miller, his father. The late Miller was an 1888 graduate of Lehighton High School. The new library dedication in 1966 was part of Lehighton's centennial celebration. The books were transported from one building to the next in an hour using a human chain.

In January 1933, the financial statement of the borough indicated police chief Mark Blank was paid $1,159 for the year; patrolman Robert Ashner, $1,155; and patrolman Harry Yenser, $1,135. The borough was patrolled on foot and at times on horseback in the early 1900s. In the 1930s, a motorcycle was purchased for street patrols along with the first police car with a bulletproof windshield in 1935. (Courtesy of Robert Fatzinger.)

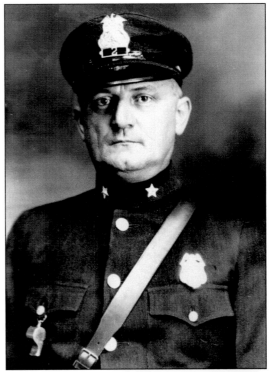

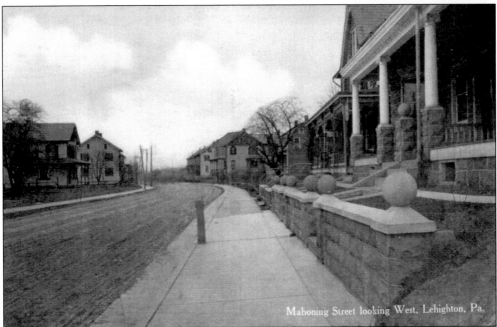

Mahoning Street looking West, Lehighton, Pa.

On April 23, 1925, final arrangements were made for the paving of Mahoning Street. The Carbon Trolley Company notified the borough of Lehighton that it would vacate all its trolley lines by May 14, 1925. The water and gas companies were notified to make pipe line installations before construction began. Solicitor Gray did the legal work of informing the property owners bordering Mahoning Street of their obligation to pay one third of the paving cost.

In October 1946, Marcus V. Young and his four sons, Fred, Marcus Jr., Woodrow, and Russell, started a bakery at 368 North First Street. Marcus Young was forced to move his bakery in 1948 because the Fisher Pontiac garage took control of the site at First and Ochre Streets. The bakery was moved to the former Edgar Paulsen store at Fourth and Mahoning Streets.

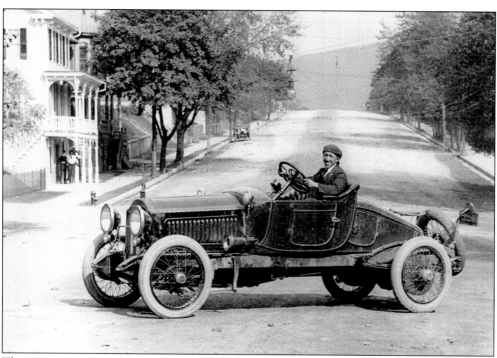

The expression on this young man's face is sheer delight as he drives his roadster on Second Street, a very popular thoroughfare, in the 1920s. The freedom of the road was the same then as it is for all generations.

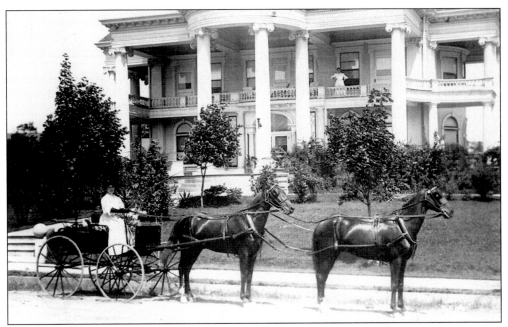

Attorney T.A. Snyder is remembered for purchasing the Michigan Building from the Pan-American Exposition in Buffalo, New York, in 1901. The mansion was dismantled and shipped via Lehigh Valley Railroad to Seventh and Iron Streets in Lehighton. Wagons were used to move the parts from the freight station. Snyder called his home Colonial Court. Sarah (Hauk) Snyder is pictured here. (Courtesy of Brad Haupt.)

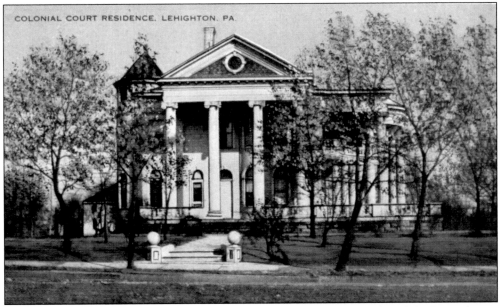

At the same time that he bought the Michigan Building, Snyder also purchased the Pennsylvania Building and had it delivered to land he owned near the Flagstaff in Mauch Chunk. Snyder was a principal for the Lehighton School District. In 1879, he began to study law and was admitted to the Monroe County Bar Association. After his death in 1914, the lumber from the Pennsylvania building was used to renovate the ballroom at the Flagstaff after a fire.

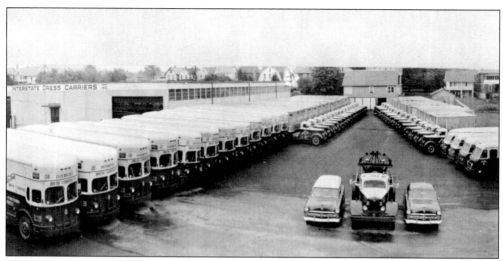

The Interstate Dress Carriers, under the direction of Sid Rothman, was located on South Sixth Street in Lehighton in the 1950s and for many years was a leading transport business for the garment industry, taking local goods to New York City. This company later constructed a large terminal along Route 902 in Mahoning Township. Today, the terminal is owned by the New England Motor Freight Company.

Pictured at center are the Interstate Dress Carriers garages. Iron Street is at the bottom, and Mahoning Street is at the top with Sixth and Seventh Streets running north and south. This photograph is from the 1960s. (Courtesy of Kenneth Seaboldt collection.)

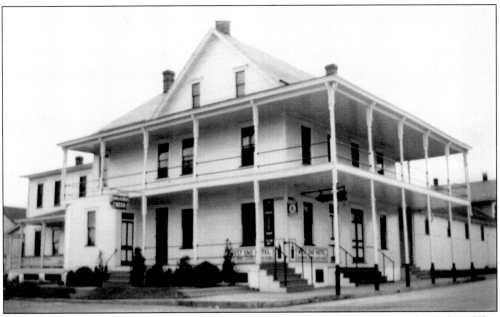

The West End Hotel at Tenth and Mahoning Streets was founded in 1890 by John Rehrig. This establishment had an excellent location alongside the Lehighton Fairgrounds. It was said that the money this hotel made during fair week carried it through the remainder of the year. Walter Semmel owned the hotel in the early 1900s, then sold it to Joseph "Chick" Diehl in August 1922. (Courtesy of Mike Takerer.)

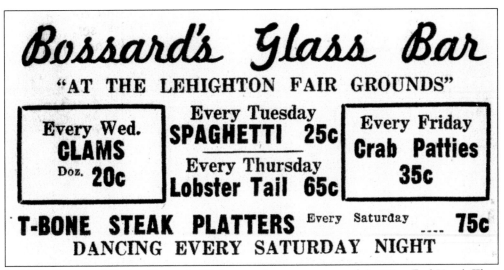

In 1945, Grant and Harlan Bossard of Palmerton became owners of the West End Hotel. They made many changes, the most popular of which was the glass bar in the barroom proper. Bossard's glass bar and dance hall became the most popular stop for World War II veterans after 1945. The Bossard brothers continued in this business until the 1980s.

On March 10, 1927, a special bus was being run from the Lehighton Park on First Street to Eleventh Street known as Ebberts Park. This housing development was advertised as "The Real Beauty Spot of Lehighton." In October 1927, Robert Sendel, owner of the Sendel Hardware Store on First Street (where the Dollar Store is now), started constructing a bungalow-type home with a unique trim in Ebberts Park. The home cost $15,000 at the time.

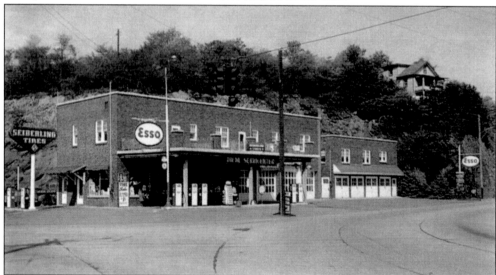

The first business located on Blakeslee Boulevard was the Leon Diehl Esso service station, in 1939. When Leon and brother David learned of the new hill-to-hill bridge and Tamaqua-Lehighton Highway, Leon purchased property on the Lehighton side from Jacoby Kistler for $3,000. He hired the bridge contractor to do excavation work for the building and gas tanks. He and his family resided in an apartment above the service station.

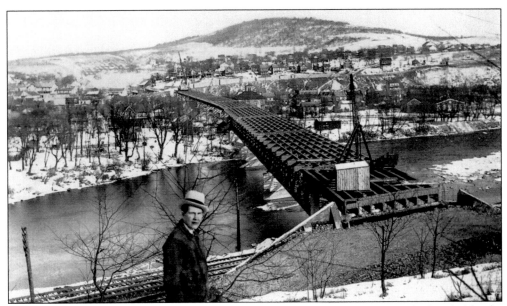

The M.A. Carty Construction Company of Phillipsburg, New Jersey, was the low bidder for this bridge job at $525,000. The bridge is 1,538 feet long and 40 feet wide, and has 15 piers. Its spans range from 65 feet to 165 feet, and it is 45 feet high. Construction began on July 12, 1937. (Courtesy of Brad Haupt.)

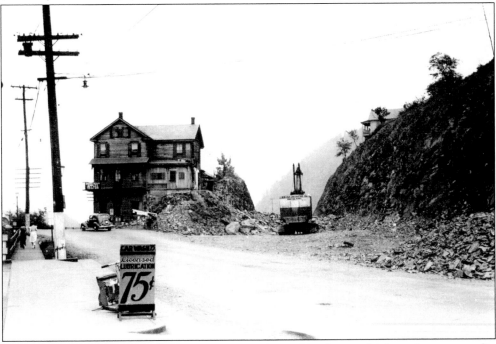

Skyway, part of the Enos Stauffer property, was condemned by the state highway department. On the Lehighton side of the iron bridge, it was located where Dunkin' Donuts is today. The Stauffers received $1,000 for their land, not including their home. The M.A. Carty Construction Company excavated Bankway to the new bridge and left the Stauffer home standing on a pile of shale 20 feet high until the late 1940s, when it was sold to Sinclair Petroleum Company.

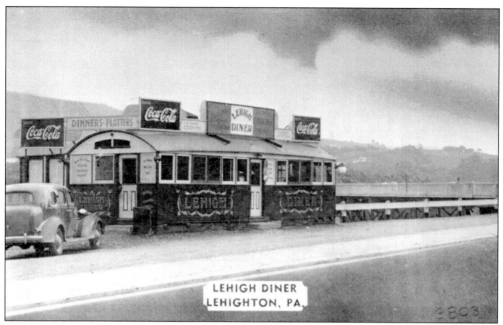

In 1940, Lehighton's first diner could be found across from Diehl's Esso Service Station. Leon Kleintop opened the unique eating establishment, which was shaped like an old trolley car and included sliding pocket doors. This unique business was located where Dunkin' Donuts stands now.

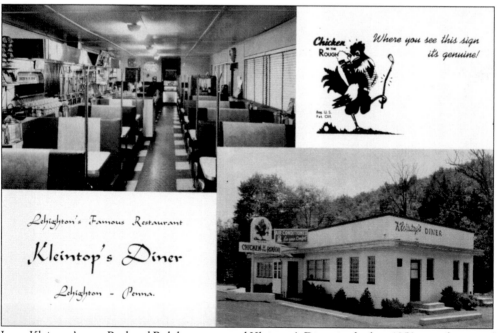

Leon Kleintop's sons Paul and Ralph constructed Kleintop's Diner in the late 1950s, a mile west of the hill-to-hill bridge on Route 443. Their specialties were ranch burgers and chicken-in-the-basket. Paul and Ralph were known for their excellent take-out platters and their specialty "Chicken in the Rough," which made the restaurant a household name.

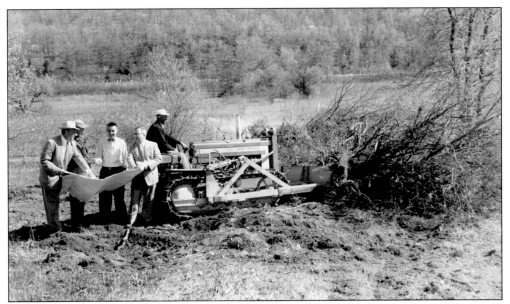

In 1957, the Lehighton Chamber of Commerce completed a drive to raise $15,000 to match state funds, which were used to construct the new Lehighton Furniture Factory building. This structure was built on the corner of Bridge and Ninth Streets in the Lehighton Industrial Park. (Courtesy of Robert Fatzinger.)

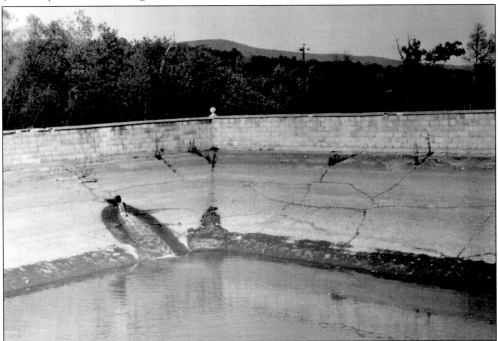

The Lehighton Reservoir is shown here. The water company requested bids for the laying of water pipes in the community and the construction of a reservoir. Contractors Cook and Mooney received the contract with a bid of $17,179. This reservoir was located on today's North Seventh Street, at the present site of the water authority garage. The reservoir was filled in in 1973 and is no longer in use. (Courtesy of Armando Galasso II.)

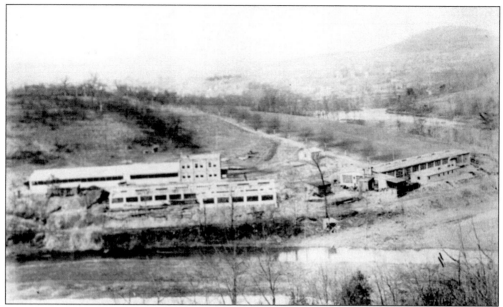

The Lehigh Foundry and Machine Company is shown here in 1905. It was constructed along the LVRR spur line in south Lehighton along Mahoning Creek at Heilman's Dam. The factory was located on the Koch farm property. A 60-foot-by-260-foot foundry and a two-story machine shop were constructed at this site. In the late 1940s, Herman Hartman opened a lumber company there. (Courtesy of Brad Haupt.)

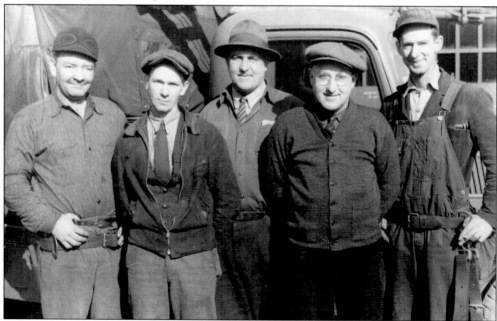

These men were employees of the Pennsylvania Power and Light Company, part of a line crew based in Lehighton in the 1940s. PP&L provided electric service to residents of Lehighton from 1928 to 1943, when townspeople voted to have Lehighton Borough take over their electrical service. Lehighton has owned and operated its own light and power utility for 70 years. From left to right are C. Blacketter, H. Teets, E. Kern, A. Metzger, and P. Kintzel.

Three

T<small>RAINFOLK</small>

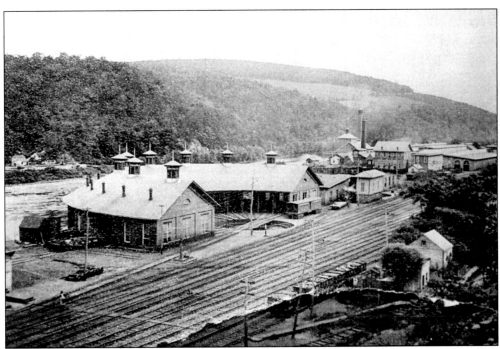

In the 1830s, this plot of land near Lehighton was known as Burlington. A terrible flood in 1862 wiped out most of Burlington after the LC&N Company dam at White Haven gave way and created a torrent of water and logs devastating the Lehigh River Valley. Nineteen people were killed and almost all of the houses, barns, and buildings were washed away. (Courtesy of Brad Haupt.)

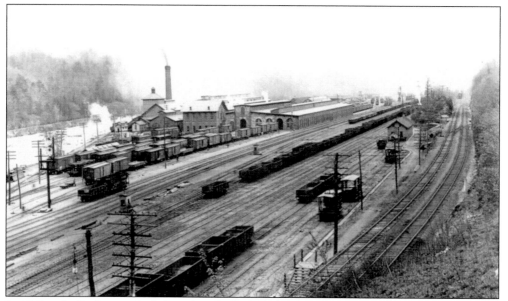

In 1878 at the Packerton Yard, the colossal job of overhauling the 1872 weigh scale was underway. This massive scale was 126 feet long and had a capacity of 104 tons. The entire tonnage of the LVRR passed over this one scale. By August 19 of that year, more than 45,000 tons of coal on 130 coal cars had passed over it. Tom Harleman was the dispatcher at Packerton at that time. (Courtesy of Brad Haupt.)

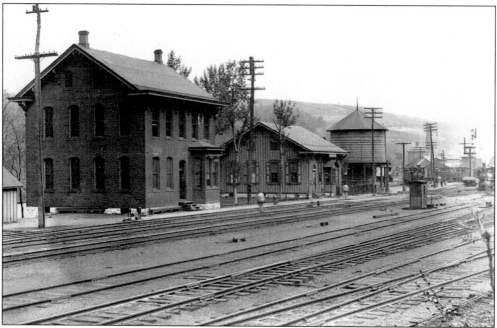

Because of the limited space available in Mauch Chunk, the LVRR had to move much of its operation south to the Lehighton Packerton operations in 1863. That same year, the LVRR purchased 47 acres of land at Burlington to create a shipping and repair center. Packerton Yard had the appearance of a small, bustling village. The brick office shown here was raised to two stories. (Courtesy of Brad Haupt.)

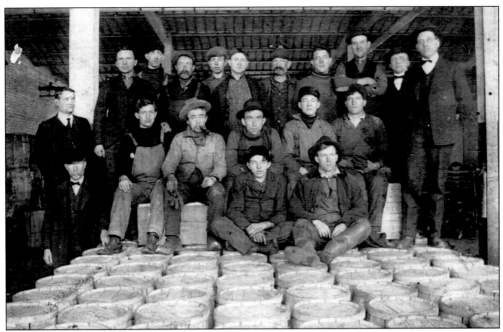

This picture shows the Packerton work crew of the Lehigh Valley Railroad in 1881. Packerton was the central point of the "immense coal traffic of the Lehigh Valley Railroad with large shops for the repair of rolling stock" according to the 1873 Lehigh Valley Railroad guidebook. Always keeping the operation up to date, the LVRR had the blacksmith shop extended 210 feet, and a new paint shop and a boiler house with a 100-foot stack were built.

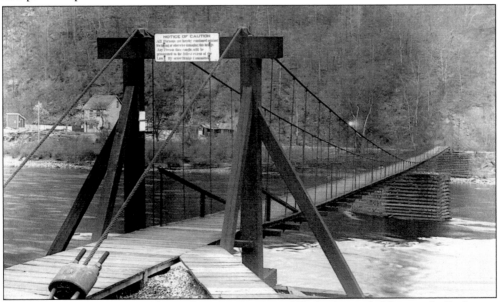

This is the Long Run Foot Bridge, no longer in existence. The bridge made life easier for Packerton LVRR shops workers beginning in May 1889 when George Enzain, a resident of Rickertsville, constructed the footbridge across the Lehigh River from Long Run to Packerton. The bridge was used until 1902 when it was washed away by a flooded Lehigh River. A sign warned, "All persons are hereby cautioned against swinging or otherwise damaging this bridge."

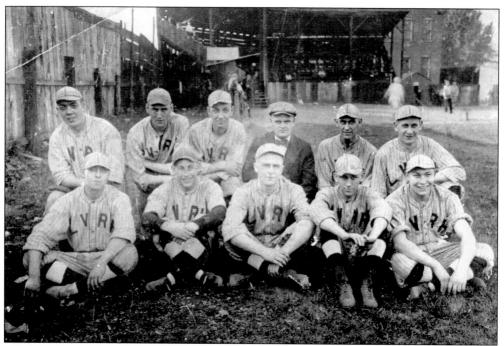

The LVRR employees were well represented in the Lehighton Baseball League with teams from the following groups: engineers, firemen, brakemen, moulders, Packerton yards, Mahoning yards, and the roundhouse. The railroad also had its own drum and bugle corps. Pictured are, from left to right, (first row) S. Kunkle, unidentified, Edgers, unidentified, and Edgers; (second row) Armbruster, Pennel, Armbruster, Krock, and two unidentified.

Labor strike participants against the Lehigh Valley Railroad are shown here on Second Street. The Packerton shop and Lehighton roundhouse workers of the Lehigh Valley Railroad went on strike in July 1922. Headed by the roundhouse drum corps, the strikers held demonstrations and marched over the main streets of Lehighton and Weissport. These strikers are heading to the rally in Lehighton Park.

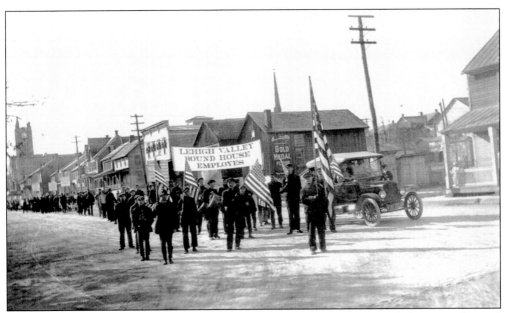

Striking LVRR employees bombed the Lehighton roundhouse in August 1922, damaging the roof. They also damaged the LVRR dam at Beaver Run Road. In January 1923, Benjamin Bowman, Raymond Flick, Lester Frey, Charles Strohl, Samuel Hosier, Lewis Keglovitz, Edward Kirk, and John Wilhelm were arrested by federal officers. Jackson Everett, Abel Rohrbach, and George Meifarth were arrested for several different bombings on Coal Street between Third and Fourth Streets.

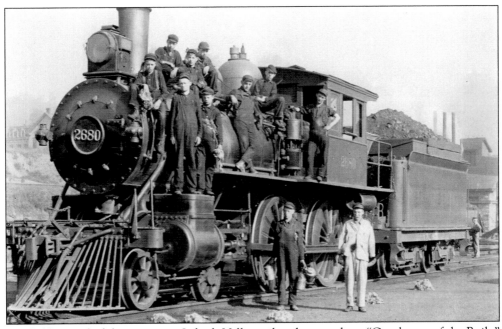

Justifiably proud of their status as Lehigh Valley railroaders are these "Gentlemen of the Rails." Each crew had its own locomotive and treated it like a baby. The most meticulous care was taken to keep the locomotives spotlessly clean and in the finest mechanical condition. Old 2680 is the locomotive but the men are unidentified in this photograph taken at the Packerton Shops.

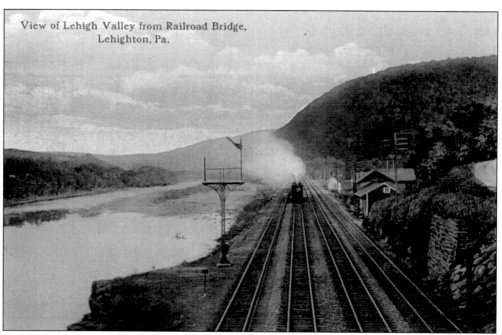

View of Lehigh Valley from Railroad Bridge, Lehighton, Pa.

Koontown was a row of houses (seen at right) located along the LVRR tracks in South Lehighton that was named after the owner of the homes, Thomas Koons. This was the red-light district of Lehighton in 1918 when the chief of police raided a number of homes. Koontown was covered with fill when the bridge was constructed. Today, Trinkle's Midas muffler shop is on top of Koontown.

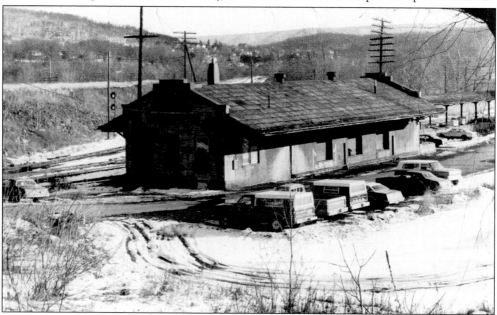

Lehighton became a railroad town in the 1850s. In 1950, this was the LVRR freight station, a busy and important part of the LVRR until the early 1960s. Early in the 1860s, the company established its repair yard and shops at Packerton. On March 16, 1864, the Lehigh and Susquehanna Railroad extended its line through Lehighton to Easton. Because of the railroad, Lehighton became one of the most thriving communities of the Lehigh Valley.

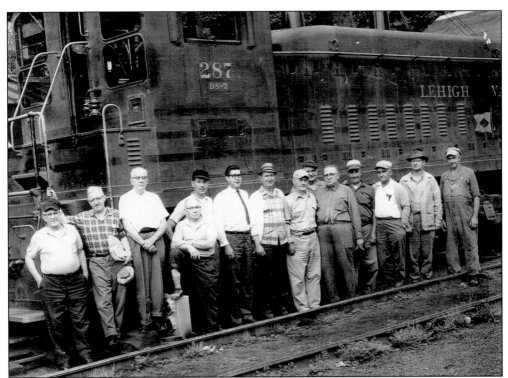

Pictured with locomotive No. 287 are Lehigh Valley Railroad employees John Fronheiser, Efie Smith, Willard Beers, Al Fire, Charley Moser, Clarence Scott, Robert Pfeiffer, Bill Gombert, Mr. Wernett, Bill Solt, and four unidentified. When LVRR passenger service ended in 1961, the Lehighton station was abandoned in Februrary of the same year; by November, the station was in a state of disrepair. It was torn down in June 1972. (Courtesy of Dick Gombert.)

This Lehigh Valley Railroad locomotive has just come under the Lehighton-Weissport Bridge. The thick trail of smoke and residual soot from soft coal–burning engines played havoc with many homemakers over the years. By the 1940s, most of the steam engines of the Lehigh Valley and Central New Jersey Railroad were replaced by diesel engines with 90 percent less emissions. Gone however was the simple beauty of that dusky plume from trains such as *Chief* or the *Black Diamond* headed for mysterious places over some of the most exquisite terrain in Pennsylvania.

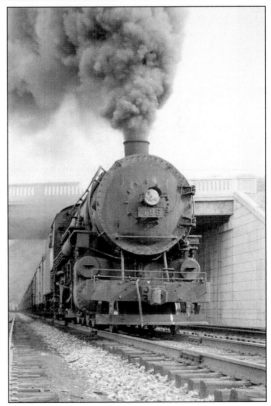

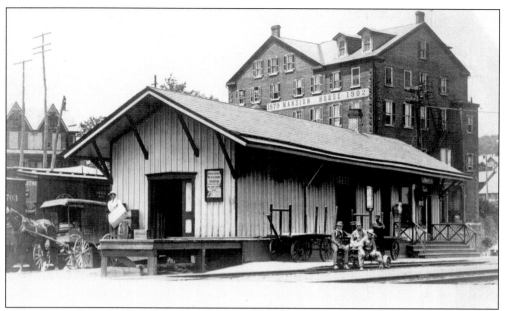

This is what the Lehigh and Susquehanna Railroad station looked like in 1867 in Lehighton off First Street. This railroad was constructed through the eastern sections of Lehighton and Weissport. The railroad was owned by the Lehigh Coal and Navigation Company but was leased to the Central Railroad of New Jersey. This familiar structure in Lehighton is gone, as is the hotel behind the station, the Mansion House.

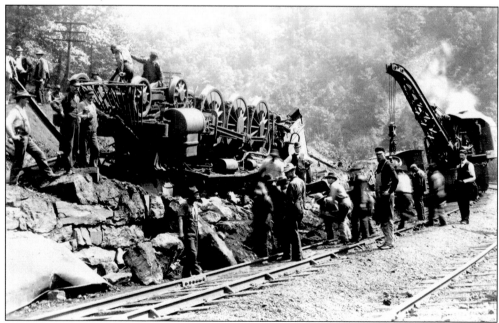

On October 3, 1890, the *Cranbury Press* of New Jersey reported, "A frightful accident occurred on the Jersey Central Railroad between Lehighton and Packerton, near Mauch Chunk, Penn. The day operator at Lehighton had orders to hold a coal train at that place, so that passenger train No. 9 could pass it. Both engines came together with such force that they were thrown over the embankment on the Lehigh Valley tracks below." (Courtesy of the Kenneth Seaboldt collection.)

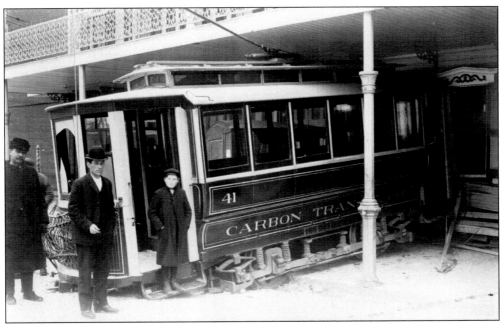

Trolley bells rang in Lehighton when a trolley route was finally established there. After a council meeting in January 1901, an ordinance was adopted by a seven-to-one vote allowing the Carbon Electric Railroad Company a franchise to operate in Lehighton. The first trolley ran on Monday, September 16, 1901, into Lehighton. During fair week in Lehighton, the trolley company ran additional cars to transport fair-goers from Mauch Chunk and the coal regions. In 1909, a special car transported the Lehighton Men's Band, hired by the fair association to advertise the fair through Mauch Chunk, Nesquehoning, Lansford, Coaldale, and Tamaqua. A large banner advertising the fair was across the front of the car. To call attention to the advertisement, the band played music as it passed through each community at a slow pace. Despite care, there were trolley accidents like the one pictured above in 1909, when a trolley car going down South Street failed to make the turn at First Street, jumped the track, and flew nose-first into the lobby of the Exchange Hotel.

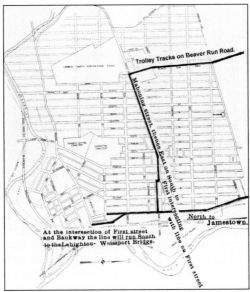

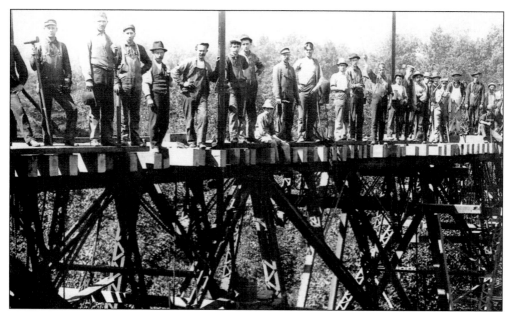

The Beaver Run trestle was southwest of the Lentz Mansion, now the Ukrainian Homestead. The trestle was 393 feet long and 80 feet above Beaver Run Creek. An inside rail provided protection if a trolley left the track while crossing—a thrill for passengers. From 1905 until 1926, people from Beaver Run used the trestle as a shortcut to Lehighton, but because of the danger, it was dismantled in 1926. (Courtesy of Brad Haupt.)

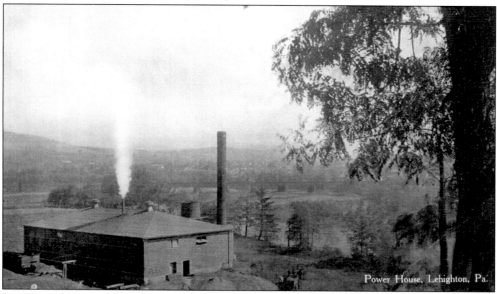

In 1901, Lehighton Borough granted a right-of-way to the Carbon Electric Railway Company for the construction of a power plant. The plant would provide electric current for a new trolley line in the borough. The power station shown here was constructed on the flats of Lehighton at South Main Lane and Railroad Street. In 1924, a fire destroyed a car barn owned by Carbon Electric Railway in Hacklebernie near Mauch Chunk. Several trolley cars were destroyed. The company replaced the lost cars with second-hand closed cars. Trolley equipment was becoming obsolete due to an increase in privately owned automobiles.

Four

A RAILROAD TOWN

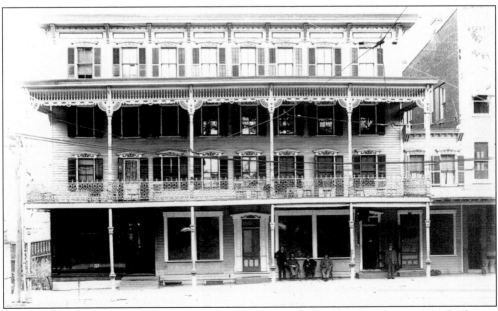

First known as the Hotel of the Township in 1809, this place of business became the Exchange Hotel, located on First Street at the present site of the Lehighton High Rise. Jacob Hagenbuch constructed the Hotel of the Township (Mahoning) on today's First Street. Hagenbuch originally came from Siegfried's Bridge, or Siegfried's Ferry. He ran the tavern for many years and was later succeeded by Reuben Hagenbuch.

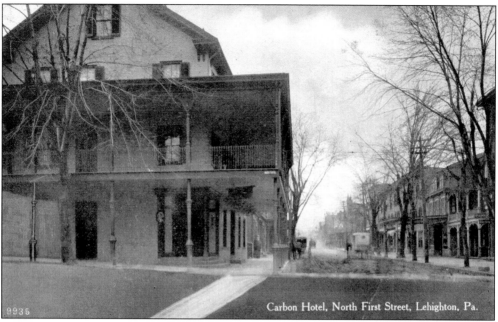

Carbon Hotel, North First Street, Lehighton, Pa.

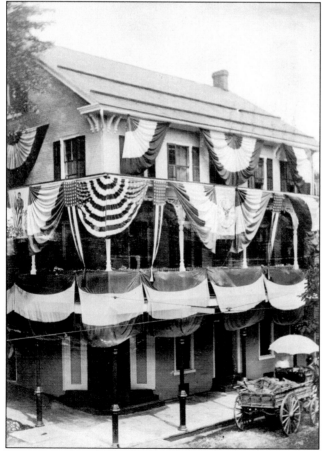

In 1842, Jacob Metzger erected a hotel at Bank (First) Street and North Street, which he named the Eagle Hotel; it became the Carbon House Hotel. A raffle was held at the Carbon House on February 26, 1887; tickets were 25¢. The prizes raffled off were a live bear and a bag of flour. Carbon House bartender Bill McCormick won the bear.

A terrible incident happened in the Carbon House in 1917 when Lehighton chief of police William Swartz, 47 years of age, was shot by 22-year-old Francis Clark in the barroom of the hotel on April 20, 1917. Chief Clark was taken to the Palmerton Hospital where he died two days later.

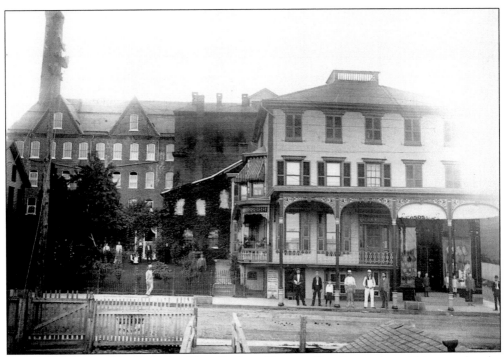

In June 1875, a fire destroyed the Obert Packing Plant on First Street, but within months, the company had a huge five-story, brick building constructed at the old site. The new building had more modern features such as large icehouses encompassing hundreds of square feet on several floors. There was additional room as well for packing, pickling, and cutting meat, and for making sausage, bolognas, puddings, and lard. (Courtesy of Brad Haupt.)

Franz Kline is one of the most celebrated American painters of the mid-20th century. A 1931 graduate of Lehighton High School, his formal study of art took place at Boston University and in London. Kline was an exemplary athlete, excelling in football and baseball, but his talent as an artist surpassed even his athletic prowess During his high school years Kline's art was versatile and could be found in places such as the high school newspaper or as props in school plays. His prestige as a first generation abstract expressionist has earned him an important place in art history. His work and his story are part of almost every college art curriculum in the world. (Courtesy of Rebecca Rabenold-Finsel.)

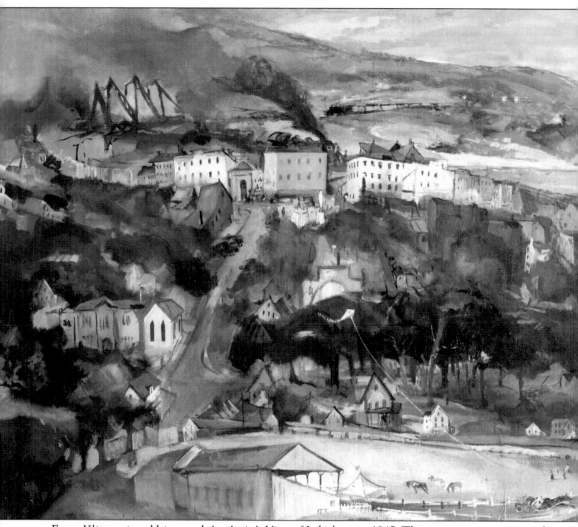

Franz Kline painted his mural *An Artist's View of Lehighton* in 1945. This stunning panorama of his hometown is one of Lehighton's best-kept secrets. The painting was commissioned by Frank Bayer, commander of the American Legion Post No. 314. Kline, a native of Lehighton, went on to become one of the world's most renowned abstract expressionist painters with paintings in every major museum in the world. In May 1962, just before he died, he was invited to a dinner at the White House by Jacqueline Kennedy, along with Andrew Wyeth, another renowned American

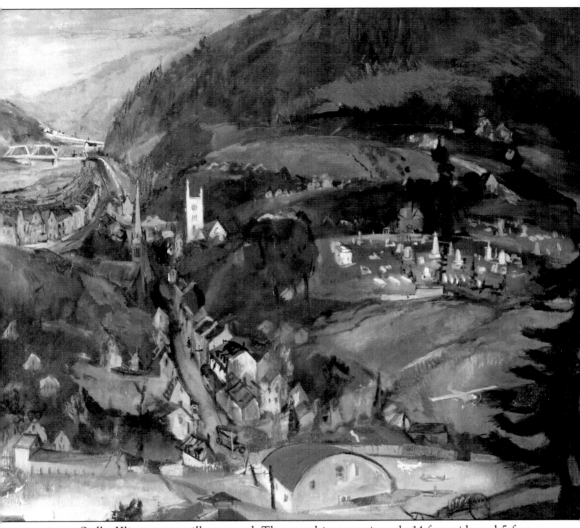

painter. Sadly, Kline was too ill to attend. The mural is approximately 14 feet wide and 5 feet high, and is housed in the American Legion dining room. In 1986, Rebecca Rabenold-Finsel, a Kline biographer, discovered his cryptic signature on this monumental painting that had been considered unsigned. Kline also painted an honor roll of area war veterans on the lower part. (Courtesy of Joshua Finsel, photographer.)

In 1865, John Kutz of Allentown married Ida Clauss of Lehighton, the daughter of Tilghman Clauss. John started a cigar and tobacco business at 128 North First Street, making cigars by hand. The Kutzs had four daughters and one son, John, who took over the business after John Sr. died in 1937. Daughter Laura married civic leader Wilbur Warner, and her sister Mae married James Whitehead, a civic and youth leader in town.

The First National Bank was in business from 1874 to 2004, including when it was the Hazleton National Bank. It was incorporated and opened in November 1874. The bank was first located in the Joseph Obert retail storeroom on South First Street. In 1876, it moved into the Francis Stocker homestead. In 1894, a brick bank building was erected.

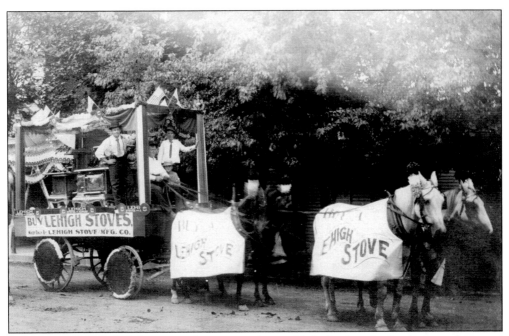

Dr. G.B. Linderman led the group of investors who established a foundry for the manufacture of stoves and iron hollow ware in Lehighton in 1867. Sufficient funds were secured and Lehigh Stove Works was incorporated in 1867. The first officers were Dr. Linderman as president and C.W. Anthony as secretary/treasurer. This company employed approximately 100 men, and Lehigh stoves, ranges, and furnaces were sold all over the world. The factory was destroyed by fire in 1931.

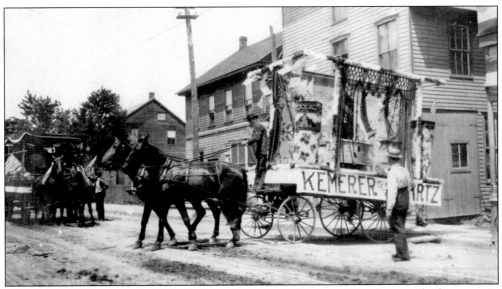

The Theodore Kemmerer and A.O. Swartz furniture and undertaking business had its start in 1885. The son of Theodore Kemmerer, George Kemmerer, and the son of A.O. Swartz, Wendell Swartz, later took control of the business together. This combination undertaking and furniture business sold a variety of furniture, parlor suites, and bedroom suites, along with caskets, shrouds, and vaults.

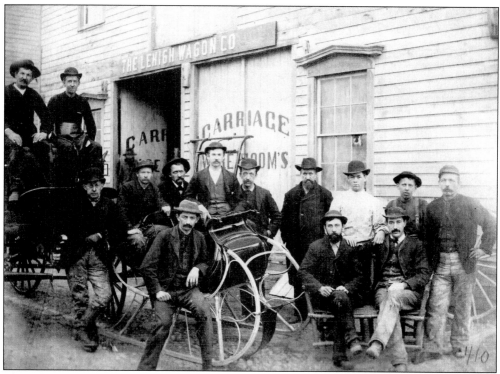

The Lehigh Wagon Company and employees are shown here in 1883. W.W. Bowman, M.A. Weiss, and Daniel Wieand were the new owners of the Lehigh Wagon Company at this time. Established by Romig and Hofford, the price of a new wagon was between $30 and $60. These wagons were especially suited for deliveries for hucksters as well as for farmers taking their families to church and other practical uses.

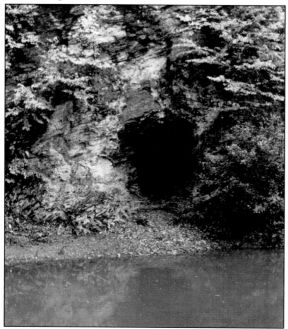

William Frantz, who according to some historians prospected for gold in Alaska, established a jewelry shop at 214 Bankway Street in 1891. Around 1900, Frantz began prospecting for gold along Mahoning Creek, immediately across from the old sewage plant. He spent a number of months tunneling into Mahoning Mountain without finding any sign of gold. One of his tunnels is pictured here.

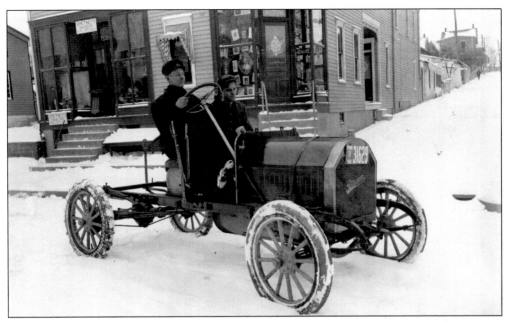

This well-bundled driver is enjoying a ride around town in his 1910 Paterson automobile, stopping on snow covered Second Street near Bretney's Bakery and Bretney's Photography Studio. Fine examples of Bretney's photography hang in the windows of his studio on the right as well as some interesting advertising. On the left side of the building, Bretney's Bakery has a sign above the door that reads Bretney's Bakery, Bread, Pie and Cake. (Courtesy of Brad Haupt.)

Valentine Schwartz, mortician and furniture maker, was one of the first undertakers in the Lehighton area in 1858 when he established a furniture business as well. An excellent woodworker, he hand-made coffins and furniture. Schwartz was born in Weisbaden, Germany. Shortly after his arrival in America he went into business with another recent arrival from Germany, Joseph Obert, who came from the town of Baden.

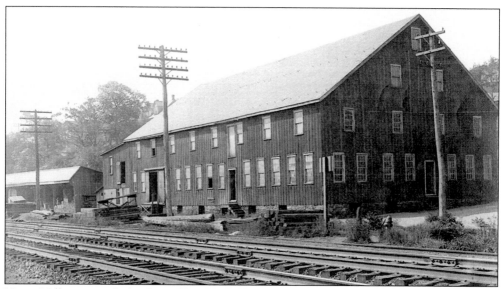

Henry Miller operated a lumber mill in Weissport in the late 1800s. He was also a Carbon County commissioner. When a new steel bridge replaced the 1862 covered bridge between Lehighton and Weissport in 1889, Miller purchased the lumber from the covered bridge. After the Weissport floods of 1901, Miller moved his mill to Railroad Street in Lehighton using the lumber from the covered bridge to construct his lumber mill. (Courtesy of Brad Haupt.)

George Geisel was born and raised in Weissport, where he established a blacksmith shop. Geisel moved his blacksmith shop to the corner of East Alley and Ochre Street in Lehighton after the devastating flood in the early 1900s. In 1906, he received a patent on a nut that was designed to not work loose when used on a carriage or wagon axle. He also had a patented horseshoe. (Courtesy of Brad Haupt.)

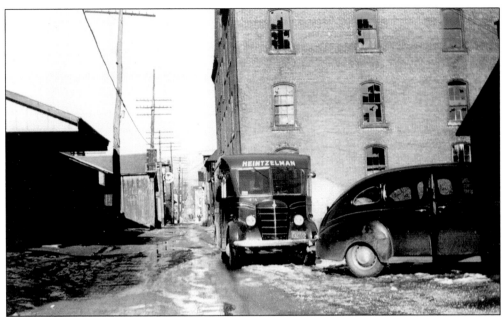

The Heintzelman meat delivery truck is parked on the side of the deteriorating Obert Meat Packing Plant. This has been the site of the municipal parking lot since November 19, 1940. William and Laura Heintzleman opened their meat market at the western border of Lehighton in 1906. In 1962, David and Joel Heintzleman took over the market from their father, Norton, and uncle Thaon. Three generations of Heintzlemans have made their reputable business a household name.

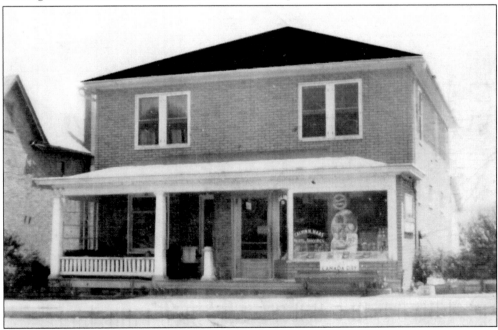

On June 6, 1938, Calvin Haas reopened his remodeled store at the corner of Fifth and Coal Streets with his wife, the former Rebecca Nothstein. Cal started his store business in 1928; he also had a bakery route for three years, selling fresh baked goods from his truck. He continued in business until April 1958 when his son Robert became the proprietor. (Courtesy of Hilbert Haas.)

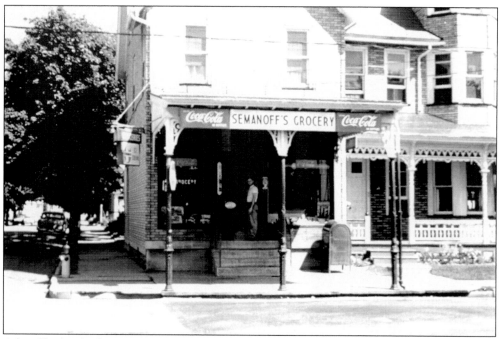

Adam Hankee had a grocery store on the corner of Fourth and Iron Streets. After his death, the business was continued by his son Leroy Hankee. In 1948, Leroy went to work for the TastyKake Baking Company and sold the store to Joseph Semanoff, who ran it until he was elected to the state House of Representatives, where he served from 1968 to 1976. (Courtesy of Mr. and Mrs. Gene Semanoff.)

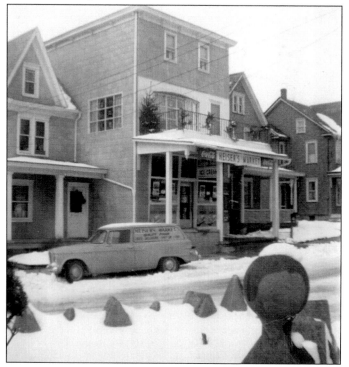

Ward Heiser's store at Second and Bridge Streets was popular for 40 years. Born in Lehighton, he graduated from Lehighton High School in 1934. He served in the Marine Corps in World War II with the 1st Division during the invasion of Okinawa and the occupation in Japan and China. After being discharged, Heiser purchased the former George Ruch grocery store, which he operated for 40 years. (Courtesy of Mr. and Mrs. Gene Semanoff.)

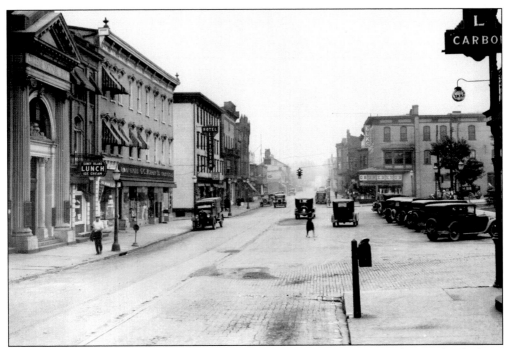

A stunning view of First Street in the 1920s shows the Hotel Carbon and the Hotel Lehighton standing sentinel. This photograph has great detail revealing the original brick used for paving and trolley tracks in this well-traveled street. Also shown are wonderful old automobiles and the business establishments that no longer exist. Not always as idyllic as this photograph, concern about extremely muddy conditions had Lehighton citizens in an uproar, in 1912 urging town council to pave immediately according to the January 4 issue of the *Municipal Journal*. (Courtesy of Michelle Ebbert Stoudt. Reprinted with permission of the *Morning Call*. All Rights Reserved.)

In 1898, a horse-drawn sleigh pauses on Second Street where the first municipal building still stands. The view includes the first Lehighton High School and the Presbyterian church on Third Street at the top of the hill. Also shown is Bethany Evangelical Church on North Street. The bundled-up driver is perhaps waiting for someone. (Courtesy of Kenneth Seaboldt collection.)

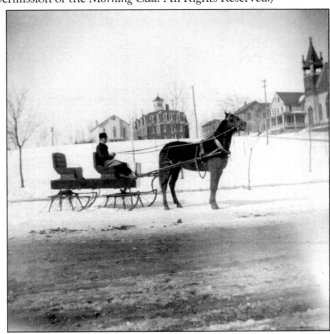

Many streets in Lehighton were illuminated with gasoline lamps in 1886. In July of that year, 26 more were purchased and installed in the borough. William Weidaw was hired to light the lamps seven days a week at a wage of $15 per month. In 1893, at the World's Columbian Exposition in Chicago, electricity was all the rage. To demonstrate Nikola Tesla's polyphase alternating current system, more than 200,000 electric light bulbs were illuminated simultaneously.

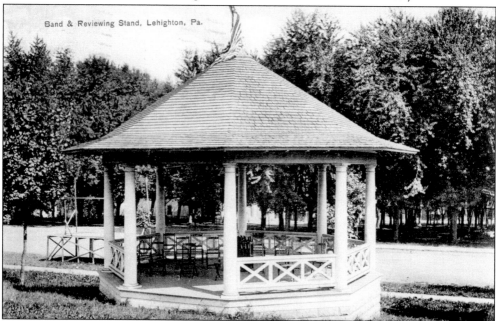

On August 6, 1905, thousands of people witnessed the dedication of the new band and reviewing stand constructed in the upper park. The bandstand was located where the present Lehighton Municipal Building is. J. Albert Durling was the driving force behind the building of this handsome octagonal bandstand. The total cost was $547.45—the lumber was $343.62, the foundation was $36.40, and George Diehl charged $97.93 for labor.

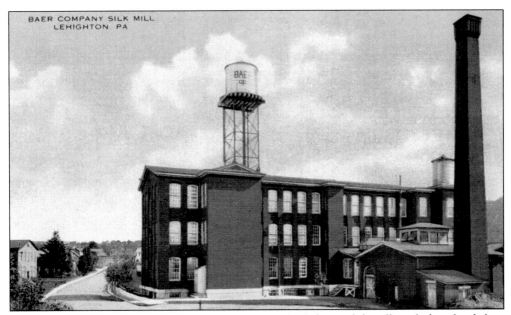

Eugene Baer was born in Patterson, New Jersey, in 1868. He learned the silk trade from his father, Jacob Baer. In 1896, Eugene established the Eugene Baer Silk Spinning Company in Riverside, New Jersey. In April 1897, a silk mill bondholders' meeting was held at Gabel's Hall in Lehighton. The five bondholder trustees were John Lentz, Henry Miller, William Ash, attorney Nathan Balliet, and John Seaboldt, all from Lehighton. Together the men reached an agreement with Eugene Baer to locate in Lehighton.

In July 1897, the Lehigh Valley Railroad constructed a siding or low-speed track along Mahoning Creek to deliver coal to Lehighton's new electric power plant and to service the Baer silk mill. The construction of these facilities required the streambed of Mahoning Creek to be moved 300 feet south—no simple feat. The new bridge was built by contractor Levi Horn, who was paid $1,700 for a bridge that was in use until 1970.

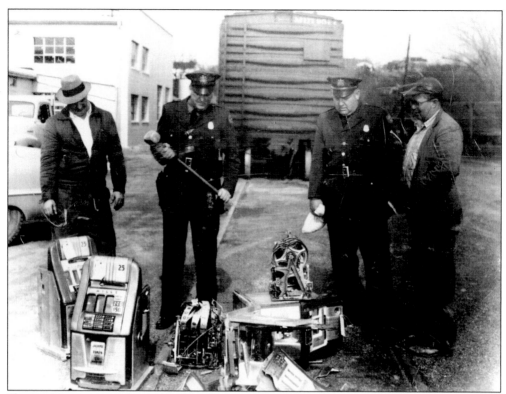

Slot machines were confiscated at the Lehighton Elks Club on February 24, 1957, by the Lehighton police. When District Attorney Carl Niehoff entered the Elks Club, he noticed the slot machines standing openly on the second floor. Niehoff immediately ordered the Lehighton police to confiscate the machines. The club was fined $250 by Judge James McCready. From left to right are John Horn, policeman Robert Ronemus, chief of police Lee Walsh, and Carl Niehoff. (Courtesy of Nicole Beckett.)

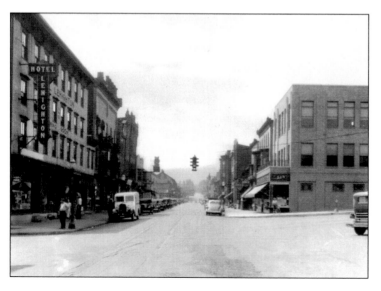

Lehighton's First Street (originally Bank Street) seems deserted in this photograph from the 1930s, unusual in this busy railroad town. First Street has always been the main shopping district in the borough. At one time an A&P store could be found in the first building on the right. Bright's Men's Store was also in the building for many years.

Five

LEGACY OF THE BRETHREN

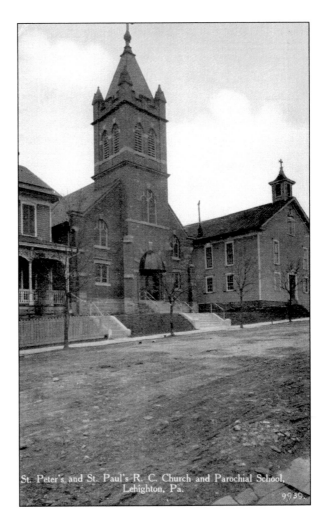

This photograph of Ss. Peter and Paul Roman Catholic Church in Lehighton dates back to 1885. In 1850, there were seven Catholic families out of approximately 250 families in the Lehighton area. These families were served by Father Freude, a missionary priest who was assigned to minister to a parish from Mauch Chunk to Berlinsville. Freude visited Lehighton monthly to celebrate mass in the South Bank Street home of Valentine Schwartz, who emigrated from Weisbaden, Germany.

St. Peter's and St. Paul's R. C. Church and Parochial School, Lehighton, Pa.

9939.

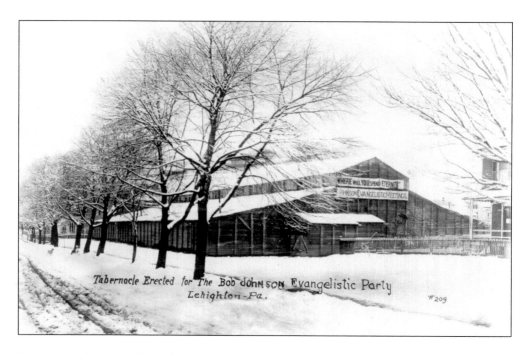

Tabernacle Erected for The Bob Johnson Evangelistic Party
Lehighton-Pa.
#209

In 1914–1915, a revival was held in Lehighton in this tabernacle constructed at Alum and Fourth Streets erected for meetings of the Bob Johnson evangelical party. Johnson's mantra was "Where Will You Spend Eternity?" Revivals and religious camp meetings were no rare event in Lehighton and Weissport back then. In the summer of 1881, a camp meeting and revival was held in Linderman's Grove in Lehighton. On the grounds were a large tent for religious services, 54 tents arranged in a circle for families, and a tent for "boarders" that would sleep 80 people. Also, there was a provisions tent where refreshments and lunches were served. Involved in this event were Rev. E.J. Miller of Weissport and Rev. B.J. Smoyer of Lehighton.

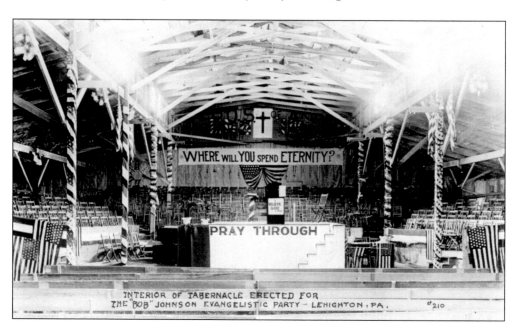

INTERIOR OF TABERNACLE ERECTED FOR
THE "BOB" JOHNSON EVANGELISTIC PARTY – LEHIGHTON, PA.
#210

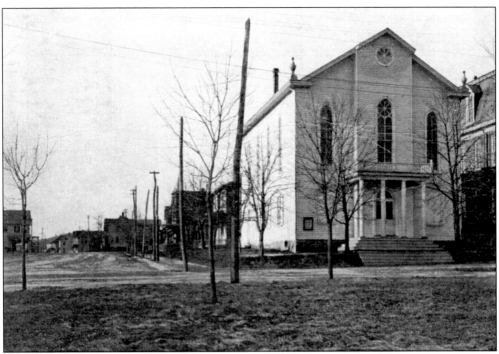

The Presbyterian church of Lehighton is shown in 1871. On December 24, 1859, eight people of the Presbyterian faith, under the direction of Rev. J.A. Dodge, met in a Lehighton schoolhouse (probably near the upper park) to organize a church. This first church was named the Gnaden Huetten Presbyterian Church of Lehighton and was placed under the presbytery of Luzerne County.

Trinity Evangelical Lutheran Church is shown here in 1872. An interest in Lutheranism surfaced in Lehighton in October 1872 when a number of residents sought permission to organize a congregation; their request was granted. Trinity church began with Rev. D.K. Kepner. Services were held in the Academy Building on South First Street until a church was built in 1873 at the corner of Northampton (Third) and Iron Streets, the Raudenbush lot.

77

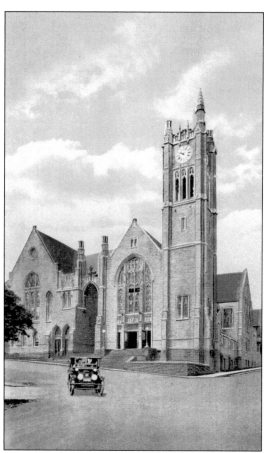

Zion Reformed Church, organized by Rev. Abraham Bartholomew in 1873, had its first constitution written in German. The cornerstone of the first church was laid in June 1876 at Lehigh (Second) and Iron Streets. The church was constructed of Holmesburg granite and took three years to build. Its tower is 132 feet high, and the clock has four dials facing the four points of the compass.

The Church of the Nazarene is pictured in 1898. It was located at the corner of Third and Ochre Streets. The first congregation was organized by Rev. P.A. Gruber in 1898. The church building was dedicated in 1905. Without a congregation, the brick church is now a school of dance for all ages.

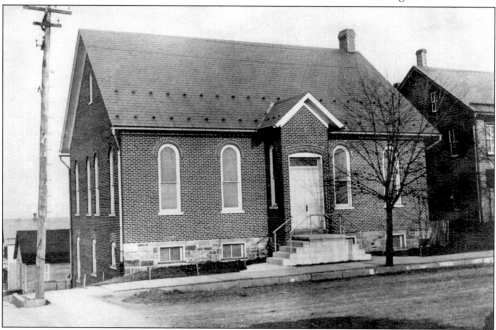

The Wesley Methodist Church is pictured in 1840. Methodism in the Lehighton area preceeded this church, when meetings were started at a sawmill in Weiss. Outside the mill, a platform and pulpit were erected out of slabs of logs by Harmon and George Horn. The first sermons were preached from this crude pulpit by an evangelical preacher named Reverend Hazard.

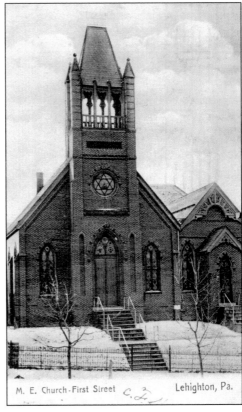

M. E. Church-First Street C. 3 Lehighton, Pa.

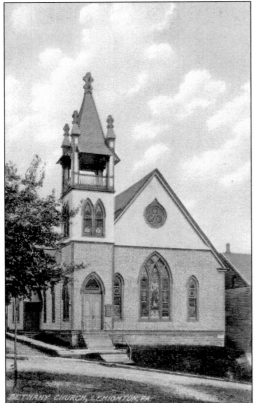

BETHANY CHURCH, LEHIGHTON, PA

Bethany Evangelical Congregational Church was built in 1895. Bethany, along with the Methodist and Presbyterian churches in Lehighton, are all located by Lehighton's upper park and have been known as "the three churches on the hill" since the late 1800s. Rev. J.P. Miller was the leader of the first Bethany congregation, which held services in the Presbyterian church building, constructed in 1872, until 1895 when this church was dedicated.

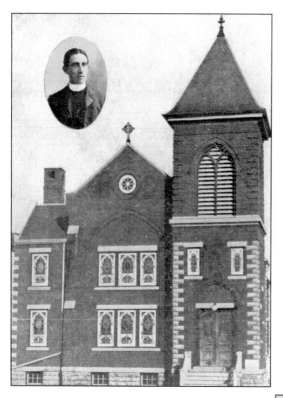

Grace Lutheran Church is shown in 1903. The church is located at Fourth and Mahoning Streets, an outgrowth of Trinity Lutheran Church, just a few blocks away at Third and Iron Streets. Part of the Trinity congregation in 1903 felt the need for a church where the service was conducted entirely in English. Thirty-three members of the Trinity congregation formed an organization for that purpose on October 27, 1903, and Grace Lutheran was formed.

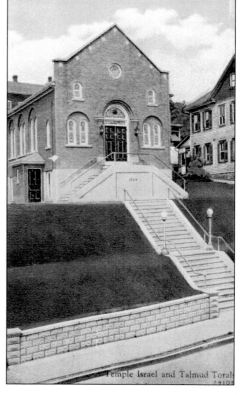

Temple Israel and Talmud Torah

Organizers of this first Jewish synagogue in Lehighton were William Cohen, Leo Gruneberg, Simon Petus, Emanuel Rauscher, William Weiss, Harry Barson, and Carl Bishop—all Lehighton businessmen. During the early 1900s, the trustees were William Weiss, Leo Gruneberg, Emanuel Rauscher, and Samuel Weiss. Emanuel Rauscher, a local druggist in 1924, organized a Sunday school in 1924 for the youth. William Cohen, a local department store owner, was chairman of the daily Hebrew school.

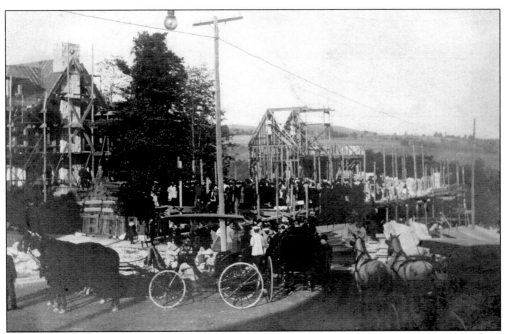

The All Saints Episcopal Church in Lehighton held its first service in the Carbon Academy Building on South First Street in 1868 under the auspices of Saint Mark's Church of Mauch Chunk. Subsequent services were held at times in Reber's hall and later in the Diefenderfer building on North First Street. In 1906, Asa Packer's daughter Mary Packer Cummings and her cousin James I. Blakeslee led the quest for a church in Lehighton. Mary contributed $50,000 for the construction of this church and vicarage. The All Saints Episcopal Church was built in graystone quarried in Bowmanstown, Pennsylvania, and trimmed in Wyoming blue stone. The first vicar was Rev. A.A. Bresee. The cornerstone ceremony for the new church was on October 10, 1906. The top photograph shows the church under construction along the steep hill of Coal Street, known as Hammel's Hill. Horses and wagons transported building materials.

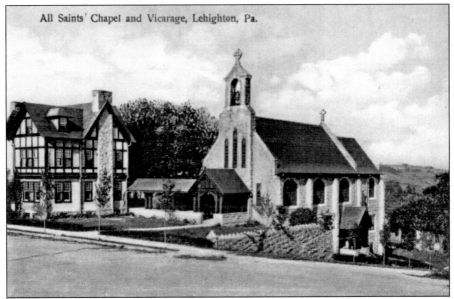

All Saints' Chapel and Vicarage, Lehighton, Pa.

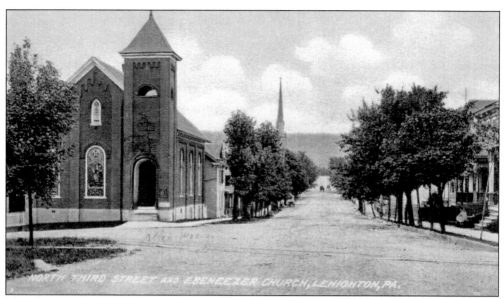

The Ebenezer United Methodist Church began in 1874 when the first missionary of the Evangelical society arrived in Lehighton. The Evangelical church and the United Brethren in Christ Church merged in 1800. Jacob Albright founded the Evangelical group among German settlers in Pennsylvania. Brother Joseph Saylor served as the first missionary preacher conducting services in the old schoolhouse located on Fourth and Iron Streets. A new church was constructed on South and Fourth Streets in 1875.

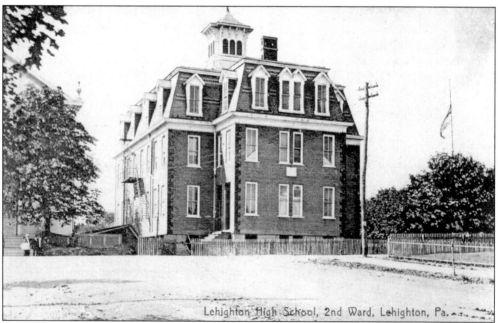

In 1872, some bold men proposed a new $25,000 brick school for Lehighton students. The school board bought a lot next to the Presbyterian church, and the school was built. There were four rooms on each floor, with elementary students on the first floor and high school students on the second floor. The third floor was for public meetings and was extra space in case the first two floors became overcrowded. High school students only had a three-year program at that time.

The Lehighton Area High School yearbook was named *Gachtin Bambil*, which means "year book" in the Lenni Lenape language. The school seal on the yearbook cover was designed by Cyril Rehrig, a 1922 graduate of LAHS who was approached by Bert David, principal, about designing a seal. The "Book of Knowledge," the "Torch of Knowledge," and an Indian head are incorporated in his design.

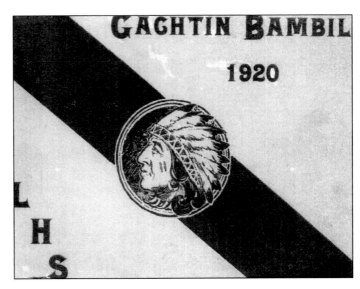

This photograph shows the Lehighton Area High School Safety Patrol in 1937, directed by Edgar Paulsen. The safety patrol went 22 years without a single injured student. Members of the safety patrol were dressed in very stylish police-like uniforms with jodhpurs to perform their duties. In 1938, the safety patrol participated in the National Safety Award Parade in Washington, DC, returning home with special honors.

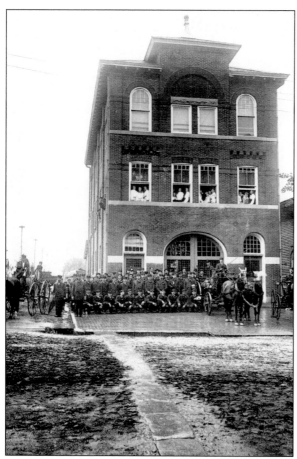

On August 24, 1874, Lehigh Hook and Ladder Company No. 1 was organized. Harry Morthimer, publisher of the *Carbon Advocate*, was president, and P.T. Bradley was the first fire chief. In June 1886, after 12 years, a meeting was held at Gabel's Hall on First Street to reorganize due to waning financial support. The meeting was called to try to boost the faltering fire company; as a result, 34 men became members and the company was revitalized.

From 1866, when the borough of Lehighton separated from Mahoning Township, until 1893, borough council meetings were held in halls and offices in the community. But in 1893, the council decided to construct a building for office space for the borough and a permanent home for fire company No. 1. The new building was erected on the corner of Cedar and Third Streets. The three-story brick structure was built by E.H. Christman in May 1893.

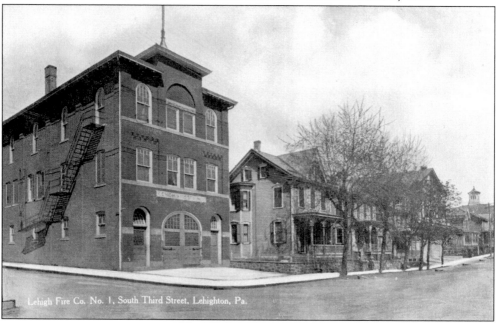

Lehigh Fire Co. No. 1, South Third Street, Lehighton, Pa.

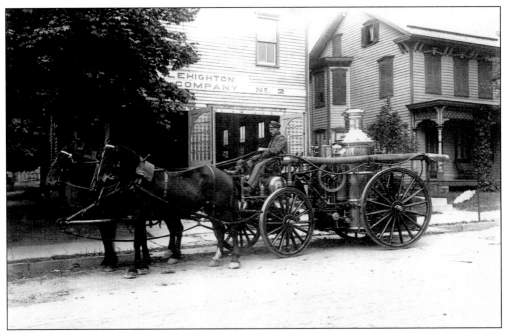

In November 1902, a group of men met at the Hochberg Hotel at Second and Bridge Streets in Lehighton to organize another fire company. The group's leader was Col. Jacob I. Blakeslee, a leading civic leader and businessman. Blakeslee was elected the first president of the fire company. By 1904, the firemen had their headquarters in the Trainer building on North Third Street at the present site of the 1916 high school building, now the borough annex.

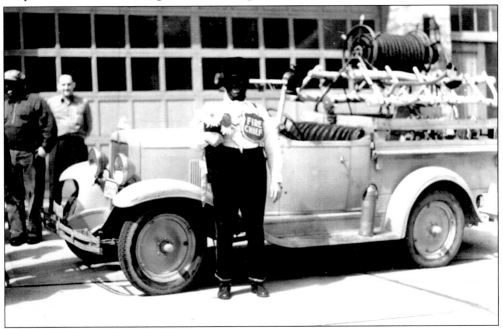

As part of the festivities at the annual convention of the four-county firemen's association in Lehighton in 1938, the fire chief poses in front of a jalopy-type fire truck. (Courtesy of Fire Company No. 1.)

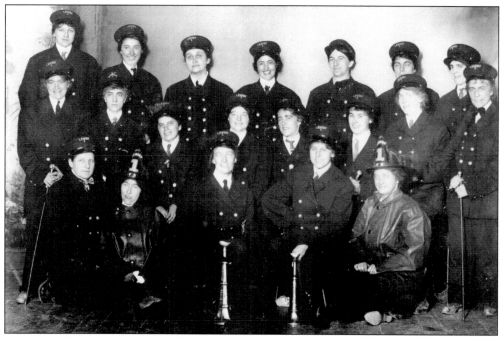

In the Lehighton Halloween parade of November 1914, the wives of the Lehighton firemen dressed in their husband's uniforms. The two antique fire horns held by women in the front row were used by firemen to shout orders to others while fighting a fire. These fire horns were typically made of brass or tin and were approximately 16 inches tall with a chain attached; some were more ornate with tole painting.

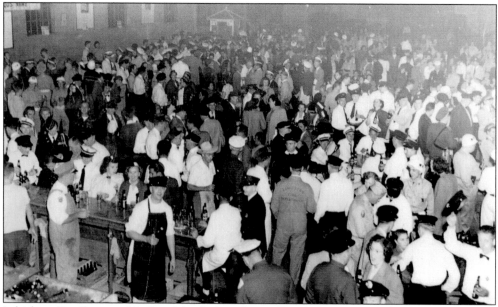

Lehighton Fire Company No. 1 and the Carbon County Fair Association joined together to celebrate the fair's Diamond Jubilee and the fire company's 75th year, shown here in 1949. On September 5–10, 1949, festivities for the Great Carbon County Fair Diamond Jubilee included one of the greatest Labor Day celebrations in eastern Pennsylvania that year, complete with fireworks.

A fine vintage vehicle is parked on Second Street right in front of the municipal building. This rare photograph has captured a moment in time for all to see. The automobile seems to be decorated for a parade, possibly one of the firemen's parades—even the tires have lavish floral embellishments. Above the American flag made of flowers is a winged creature, possibly an eagle.

George Harmon was born in 1894 in Delaware and came to Lehighton in 1919. He was a shoemaker by trade and had a few shops at various locations from 1919 until 1960 when he died. In 1955, when the flood hit Weissport, Harmon repaired 100 pairs of shoes for flood victims without charge. (Courtesy of Lehigh Fire Co. No 1.)

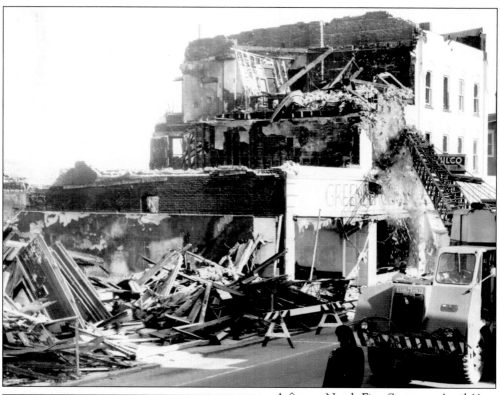

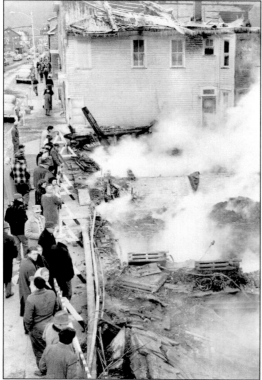

A fire on North First Street on April 11, 1963, Good Friday, was the second worst fire in the history of the community. Twenty-one people were left homeless, and seven business places were destroyed, including Lehighton Hardware, Greenberger Furniture Store, Stewart Grocery Store, Web TV Appliance Store, Swap Shop, Faenza Shoe Store, and the Trexler Hotel. (Courtesy of Lehigh Fire Co. No. 1.)

On Wednesday, December 21, 1955, Lehighton suffered the worst fire calamity in the history of the community when eight South First Street business establishments and residences were obliterated by flames. More than $250,000 in damages was done and 22 persons were made homeless. Businesses ruined were Frank Bayer's paint store, the office of Justice of the Peace Joseph Williams, Chester Mangold's home and Modern Cleaner Store, Beth Ann Dance Studio, and Clarence Warner's photo studio. (Courtesy of Lehigh Fire Co. No. 1.)

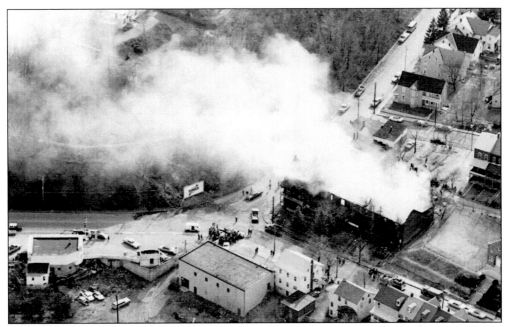

On March 28, 1975, a row of nine brick homes on South Bankway Street were completely destroyed by fire, leaving 70 people homeless. The fire broke out at about noon and was not under control until 3:15 p.m. It began in the attic of a home in the center section of these dwellings and spread across the roofs. A 100 percent loss, the brick walls were weakened, and the row had to be demolished. (Courtesy of Lehigh Fire Co. No. 1.)

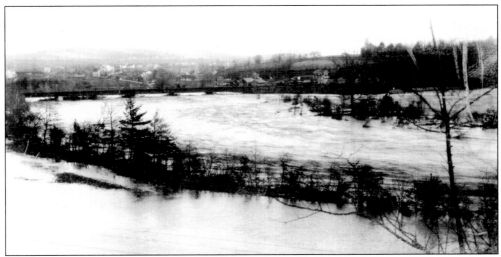

The small community of Weissport has felt the fury and destruction of the Lehigh River flood waters many times. Weissport is only 10 to 15 feet above the level of the Lehigh River, and without guard banks until the early 1900s, the community suffered tremendously throughout its early history. This photograph shows the Lehigh River almost covering the Central Railroad Bridge in 1901. The LVRR suffered considerable damage as well when many of its tracks were washed away.

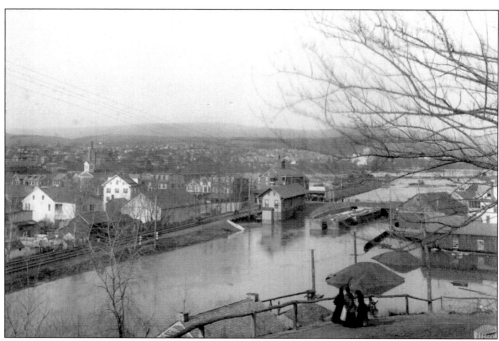

This photograph shows flood damage in 1901–1902 from Union Hill looking toward Weissport. Pictured are Nathan Snyder's coal yard, the canal bridge, canal boats lodged against the bridge, and the Central Lunch Room. Note there are no guard banks. (Courtesy of Brad Haupt.)

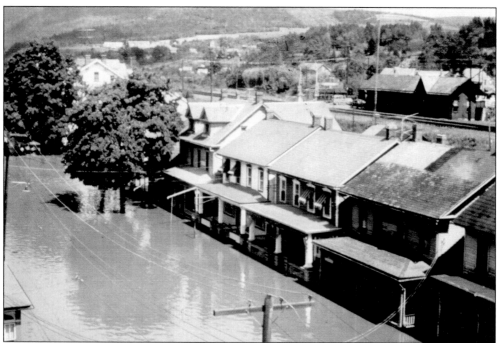

This was the devastation of the 1955 flood in Weissport on August 18 when the entire population of Weissport was evacuated after Hurricane Diane dumped enough water on the upper Lehigh Valley to raise the Lehigh River to 19.55 feet. The flood stage at Weissport was 14 feet.

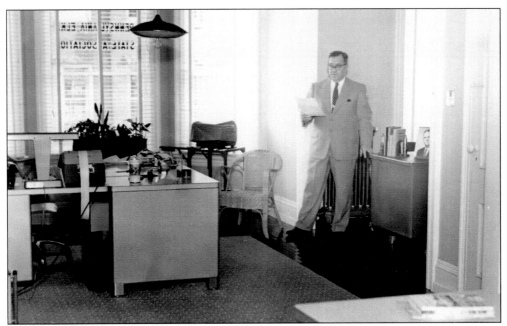

Wilbur Warner, pictured in his Lehighton office, undertook the Herculean effort to have a hospital constructed in Lehighton. The *Lehighton Evening Leader* called Warner "a man of courage, vision and ability with a faith in humanity." Warner raised millions of dollars for community projects. It has been said that if one were to build a monument to Wilbur Warner, the hospital would be that monument. Warner was instrumental in establishing the Lehighton Library, the Lions Club, and the National Guard unit in Lehighton.

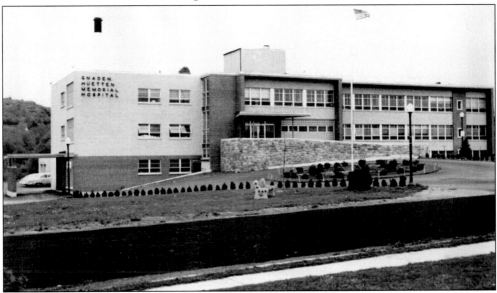

In 1946, Lehighton residents chose a new hospital as a memorial for the 216 men and women from Carbon County who perished in World Wars I and II. Mr. and Mrs. Thomas Evermon donated a three-acre tract of land between North Eleventh and Twelfth Streets for the hospital. In 1949, the hospital association reached its goal of $750,000 and received a $100,000 grant from the S.S. Kresge Foundation of Detroit, Michigan, in return.

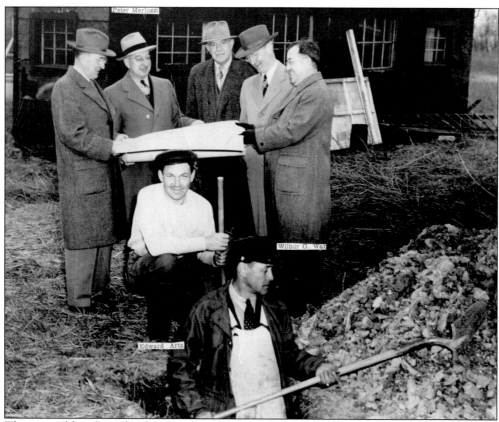

The ground-breaking for the Gnaden Huetten Memorial Hospital was the first step to the construction of the community hospital in Lehighton. Peter Merluzzi, Wilbur Warner, Edward Arts, and James Foster were four of the men who spearheaded the project. The total cost was $800,000. The hospital had 56 beds, 10 bassinets, and 18 physicians on staff. Dr. Joseph Nosel of Sunbury was the chief surgeon with Dr. Homer Fegley assisting. (Courtesy of Robert Fatzinger.)

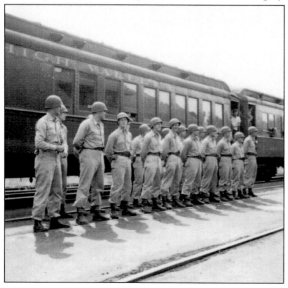

Pictured in June 1948, these Lehighton men became members of Company B, 164th Military Police Battalion under the command of Capt. Charles Foulsham. They were the first guard unit in Lehighton. Members of the first unit were Edward Balliet, Vincent Beck, Paul Dougher, Melvin Everett, Charles Foulsham, William Garrett, Francis Gridely, Kermit Heiland, George Herman, James Hottenstein, Charles Koons, Ralph Kramer, Carl Merluzzi, Robert Moyer, Blaine Rabuck, Robert Rehrig, Donald Roth, Dale Schnell, Robert Serfoss, and Millard Thomas.

These Lehighton area men, members of the National Guard, were photographed at Camp Perry, Ohio, in 1950. They are, from left to right, (kneeling) Millard Thomas, Paul McFarland, and Lamont "Mike" Ebbert; (standing) Carl Merluzzi, Robert Rehrig, and George Hartman. (Courtesy of Wilbur Warner collection/Grant Hunsicker.)

In 1948, Wilbur Warner turns over the first shovel of ground at 1000 Bridge Street in Lehighton accompanied by Bill Garrett and Paul Dougher on land purchased by the state of Pennsylvania for a new National Guard Armory. Warner was the Lehighton postmaster and was instrumental in securing a National Guard unit for Lehighton. (Courtesy of Wilbur Warner collection/Grant Hunsicker.)

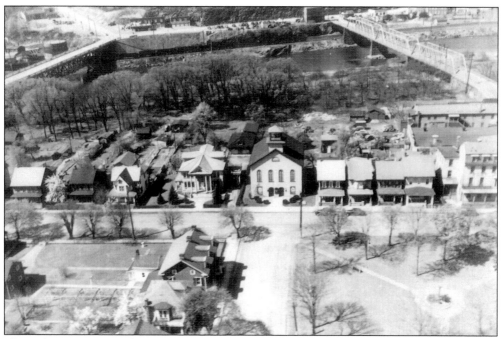

Shown here is a spectacular aerial view of Weissport from around the 1940s. In the foreground is Jacob's church, the Mayes-Melber Funeral Home on Franklin Street, and various residences. Both bridges connecting to Lehighton are visible, as are the Lehigh River and Weissport Park.

Maj. Gen. Bert A. David, US Army, attends a banquet at the Lehighton American Legion post. He was born on the Fourth of July in 1924, the son of Mr. and Mrs. Bert B. David Sr. Bert Jr. graduated from Lehighton High School in 1942 and received a Congressional appointment to the United States Military Academy at West Point. He graduated from West Point in 1946 and began his military career in Japan with the 24th Infantry Division.

Pictured on April 11, 1946, is Maj. Gen. Bert A. David (left), commanding general of the United States Army Transportation Corps in Fort Dix, New Jersey, with Donald Anthony, Marvin Sensinger, and Lawrence Barry at the Lehighton American Legion Post. The annual banquet of the Last Man's Club—veterans of World War I—was called to order by comrade Robert Reabold. Major General David acted as chairman pro tem and explained the purpose of a Last Man's Club to veterans of World War II.

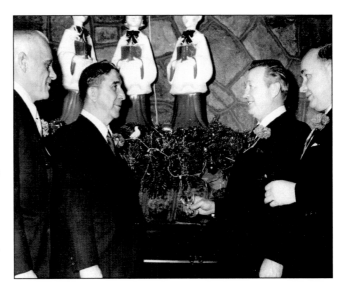

The first regular meeting of the Last Man's Club of World War I was held on November 12, 1938, at the American Legion post in Lehighton. The speaker for the occasion was brother and comrade Bert B. David, who gave a very inspiring address. President Wilbur Person presented a bottle of Courvoisier, "the Brandy of Napoleon," to the club. This bottle was to be the property of the last man alive, to toast his departed comrades. (Courtesy of Carlos Teets.)

The Korean Last Man's Club meets in June annually to observe the date North Korea invaded South Korea. The Korean War started on June 25, 1950. More than five million Americans, including the 40 men in this photograph from the Lehighton area, served in the conflict over the next three years until an armistice was signed on July 27, 1953.

Six

TRANSCENDENCE

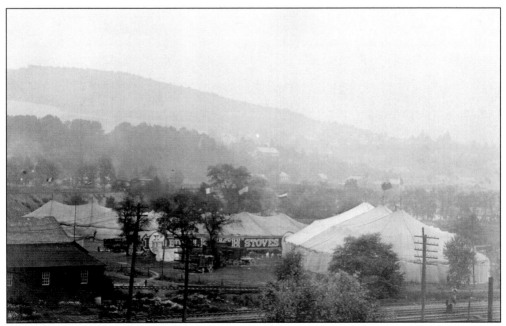

John O'Brien's circus performed two shows on October 21, 1876, in Lehighton. This "Menagerie, Museum, Circus and Hippodrome" featured one entire mile of gilded chariot cages, two bands, "an army of wild beasts," and "the largest African Eland living in captivity." This circus traveled by horse and wagon from town to town, not by rail. A large banner advertising "Buy Lehigh Stoves" can be seen on the tent behind the tree. Lehigh Stove Company is at lower left. The circus was held in the flats behind First Street near where Dunbar Bottling is today. The tents were set up in the baseball field.

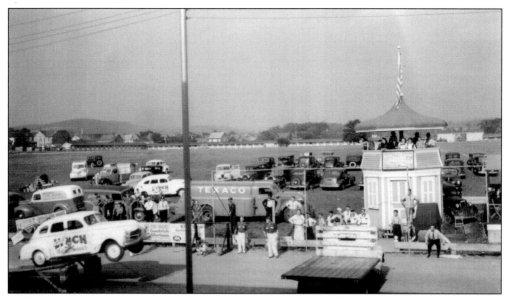

By September 4, 1945, World War II was over, and 35,000 people attended the opening of the Carbon County Fair. The main event, Buddy Wagner's Hell Drivers, opened the annual festivities and made the fair that year a huge success. Over the years, fairgoers have enjoyed Joey Chitwood's demolition derby, a variety of auto races, horse harness racing, and shows from Atlantic City, New Jersey's famous Steel Pier produced by George Hammet. Note the judges' stand at right, which has recently been restored to its original appearance for a new generation to enjoy.

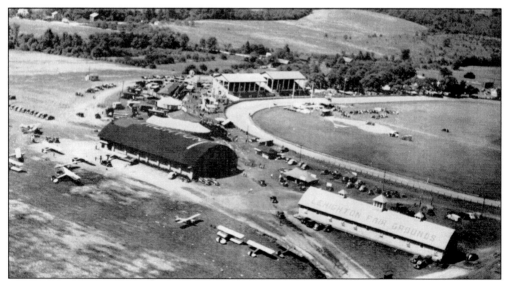

The Carbon County Fair began in 1858 when the Carbon County Agricultural Society was formed. As early as 1918, airplanes were a big attraction at the fair as the Lehighton Airport was adjacent to the fairgrounds. Many fairgoers would pay between $5 and $20 for an airplane ride and see a magnificent aerial view of the area. Throughout the history of the airport, the most active period was fair week.

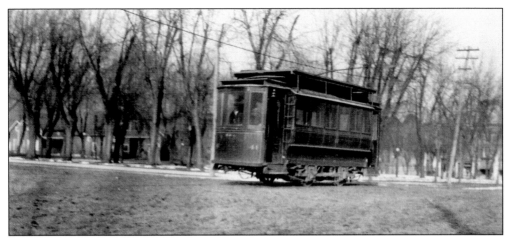

Lehighton's trolley is seen here on South Street riding up along the lower park. After 1901, the trolley became a reliable form of transportation for area residents, giving a lift to events such as the Carbon County Fair. In 1905, the trolley company and the LVRR both advertised special train and trolley excursions to the fair. In 1933, the Civil Works Administration had 44 men remove the trolley rails along Bankway, the last traces of the trolley's existence. (Courtesy of Kenneth Seaboldt collection.)

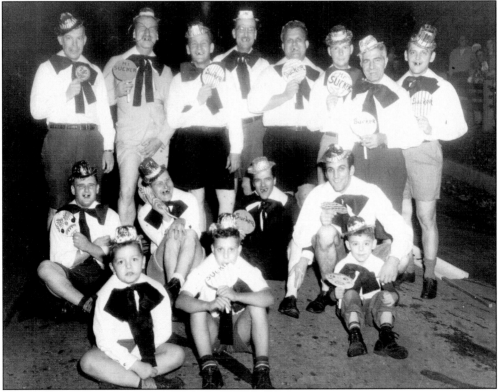

Clowns from the Carbon County Fair in Lehighton? No, these men are members of the Lehighton AMVETS posing with their children after marching in a parade in the late 1950s or early 1960s. In the back row from left to right are Gordon Hontz, Kenneth Seaboldt, Mr. Harleman, and Russell Jacoby. The rest are unidentified. (Courtesy Kenneth Seaboldt collection.)

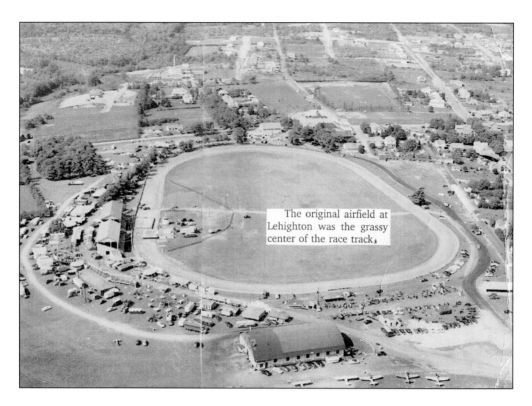

The original airfield at Lehighton was the grassy center of the race track.

On July 20, 1900, fairground improvements began. The original airfield at Lehighton was the grassy center of the racetrack. The most important change, and the most expensive, was having the racetrack moved 30 yards east. This was necessary to meet the regulations of the trotting association. On July 20, 1900, a new modern grandstand, which was 40 feet by 100 feet in size, was built at the Lehighton Fairgrounds. Underneath were offices for the fair officials. The stand was placed in the southwest so the afternoon sun would not bother fair-goers. Directly opposite the grandstand, a new judges' stand was constructed. On July 14, 1922, the Radar Construction Company of Catasauqua was building a new grandstand that was larger than the old one. A spacious stage platform was constructed across the racetrack from the new grandstand; underneath were new dressing and storage rooms.

In September 1956, the first horse show was held at the Lehighton fairgrounds. Trophies, ribbons, and other prizes were awarded to the winners in the open horse show.

The 118th Carbon County Fair held on August 11, 1992, was the last. The fair association decided to sell the 47-acre fairgrounds property for $697,000 by a vote of 247-163. Over the years, the midway show was the main attraction, provided by Amusements of America and similar firms that specialized in fun and food for all ages.

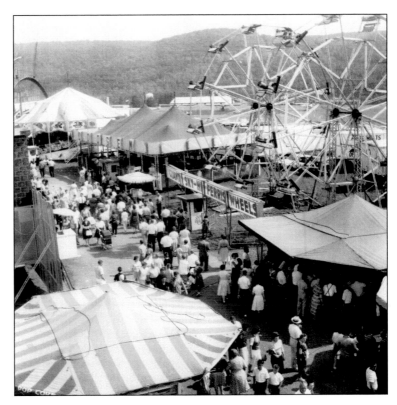

By 1995, the Lehighton Fairgrounds were stripped of all stables, grandstands, and refreshment stands. Also, the airplane hangar fell into serious disrepair. The hangar was a large iron structure purchased in 1928 from the Carbon Furnace Company. Initially used as an auto display building, eventually it was turned into an airplane hangar. The Lehighton School District administrative office was constructed here in 1995.

An Army airplane is shown here at the dedication of the Lehighton Airport. In May 1938, the 20th anniversary of airmail service was marked by a special flight from the Lehighton Airport. Airmail bags from local post offices were flown from Lehighton to Allentown to commemorate this anniversary. Local postmasters who provided mail for this reenactment were Calvin Steigerwalt of Andreas, George Arner of Weissport, George Rex of Ashfield, and Wilbur Warner of Lehighton.

Don't Forget

the Dedication of

Martin Jensen Airport Hangar

JULY 20-21, 1929

Graham McNamee will announce the dedication ceremonies.

Capt. Martin Jensen and wife will participate in the dedication.

LEHIGHTON AIRPORT

Martin Jensen brought excitement to the Lehighton area, gaining support for his aviation enterprise. A record-breaking pilot, Jensen won second place in the Dole Derby sponsored by the Hawaiian Pineapple Company in 1927. He came in second crossing the Pacific from California to Hawaii in one hour and 58 minutes after Arthur V. Rogers won first place. Jake Arner's name is synonymous with longevity, dependability, and safety in aviation, just some of the reasons that the Carbon County airport is now the Jake Arner Memorial Airport.

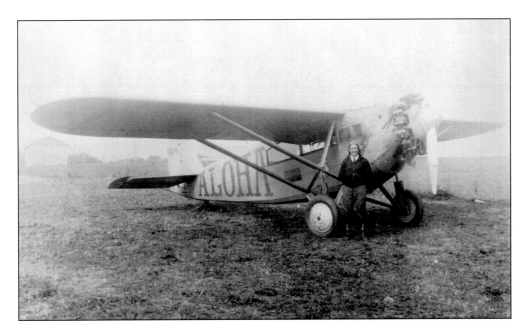

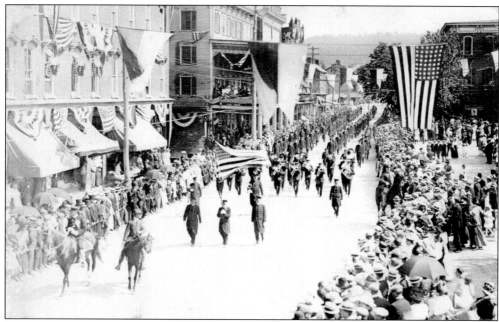

The 1927 firemen's convention was hosted by Mayor Howard Seaboldt on June 18, 1927. Mayor Seaboldt welcomed 25 fire companies to Lehighton for the firemen's parade. The *Lehighton Evening Leader* reported that thousands of people would be lining the parade route. It was an event so special that just attending it could get the newspapers to take notice. On June 23, 1927, the *Kutztown Patriot* reported, "H. P. Boger attended the firemen's convention at Lehighton Saturday."

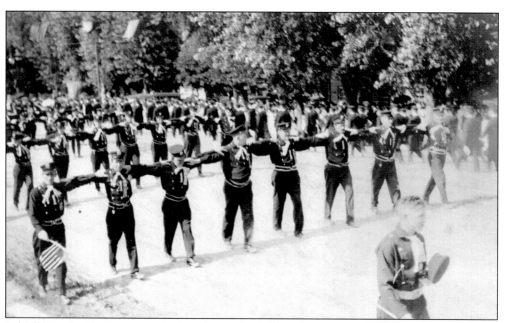

Lehigh Fire Co. No. 1 was organized on August 24, 1874, and was reorganized in 1886. In September 1887, the fire company had 25 men march in one of the first firemen's parades (pictured). The Lehighton firemen were dressed in their brand new blue woolen uniforms for the event.

The colors are passing the reviewing stand at Weiss Square during a gala armistice celebration featuring 7,000 American Legion men from all parts of the state. On the 11th hour of the 11th day of the 11th month of 1918, an armistice went into effect between Germany and the Allied nations. On November 11, 1919, Armistice Day was commemorated for the first time.

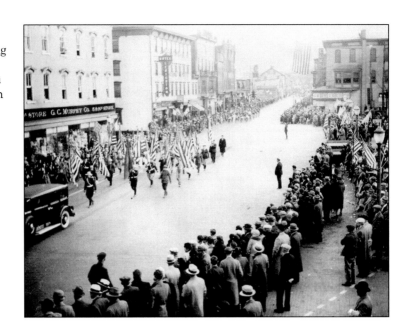

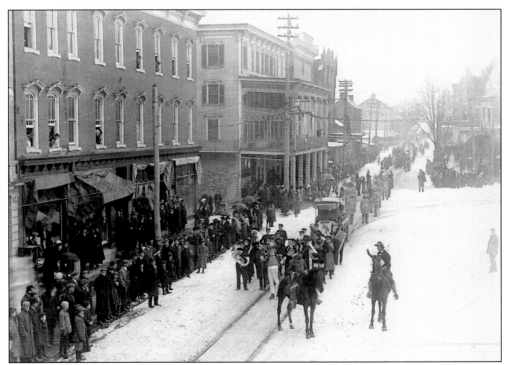

A historic Mummers celebration took place in Lehighton to welcome in the New Year on December 31, 1910, involving participants in masks and other disguises. George Shoemaker, Orville West, Ed Carl, and G. Frey did the planning for the 1910 parade. Bands participating were the Lehighton Cornet Band, the Lehighton Band, the Weissport Cornet Band, the Patriotic Order Sons of America Band, the Parryville Band, and the local drum corps. (Courtesy of Brad Haupt.)

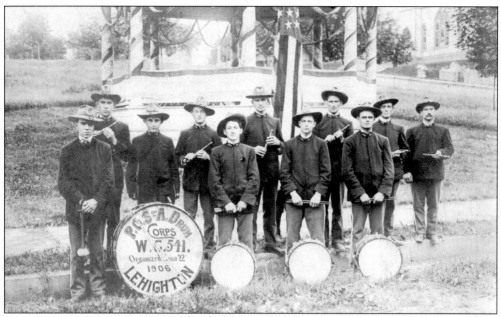

The Lehighton Camp of the Patriotic Order Sons of America was founded in 1890, when the organization had reached the height of its popularity in Pennsylvania. POS of A members were all male, white Protestants, and their meetings included Bible readings, the Pledge of Allegiance, and the singing of patriotic songs. Washington Camp No. 541 was in Lehighton, and Washington Camp No. 122 was in Weissport. The Lehighton group met where the Mallard Market is located.

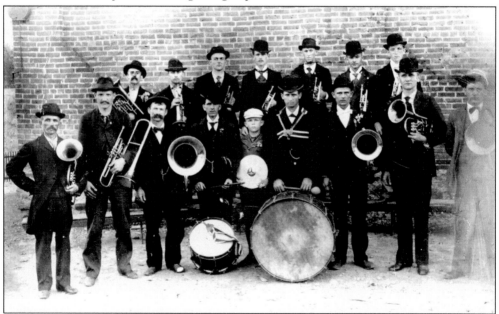

During the last week of July 1912, James I. Blakeslee, founder of the Boys Band, took 50 members to Lake Mineola at Brodheadsville. Here, they concentrated on honing their musical skills. Blakeslee paid for brand new tents, the cook and kitchen facilities, and all costs involved in the weeklong camp. That year, Blakeslee also purchased uniforms and new instruments for the Boys Band. (Courtesy of Robert Fatzinger.)

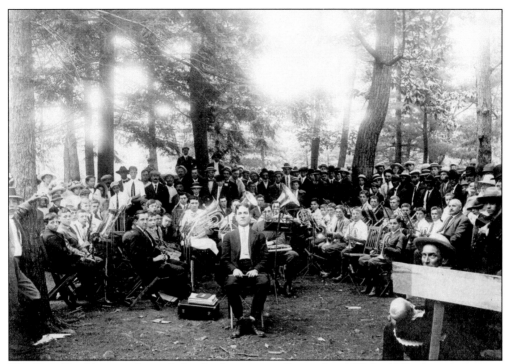

The Boys Band began rehearsals for the first time in September 1911. In 1912, the organization was chartered and membership numbered 35 boys with a junior band of 15 boys. The purpose of the Boys Band was to give boys in Lehighton and surrounding areas a musical education and an opportunity to develop character. Girls were invited to join the band in 1980. (Courtesy of Robert Fatzinger.)

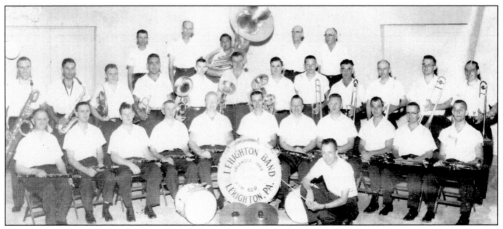

The Lehighton Band celebrated its 85th anniversary in 1949. At that time, the band headquarters were above the Hazle Maid Dairy Bar on North Street. Today, the Lehighton Library is located at that site.

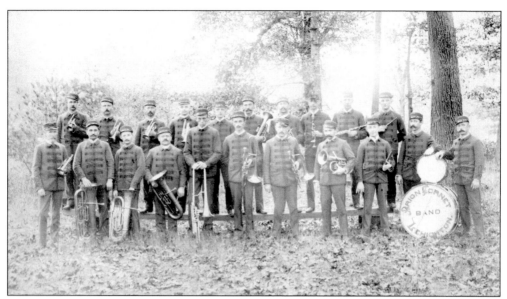

According to a March 1929 issue of the *Lehighton Evening Leader*, the first attempt to organize a band in Lehighton took place in 1864. The report indicated that in that year, a group of men met in the old schoolhouse on North Third Street and became known later as the Lehighton Band. The band director was Sylvester Engleman, and the manager was Zach Homm. Many of the members worked for the LVRR in Packerton. (Courtesy of Robert Fatzinger.)

In 1890, J.M. Rehrig, manager at Daniel Wieand's new opera house, charged admission prices ranging from 10¢ for children to 30¢ for reserved seats. Wieand sold the opera house to Andrew Bayer the same year. Bayer had an interior decorating business in Lehighton. On January 5, 1908, the first motion picture was shown in the former opera house, now owned by the Bayer family. For better acoustics, a metal ceiling was installed in 1909. (Courtesy of Brad Haupt.)

On October 20, 1922, the little red house at Second and South Streets—a landmark for many years—was razed. It was the first time in Lehighton that a steam shovel was used for a job. On November 10, 1922, ground was broken for the Park Theater, which had a capacity of 1,000 people. For years, John Medernach had a shop nearby; his specialties were his famous hot dogs and Medernach lemonade. (Courtesy of Robert Fatzinger.)

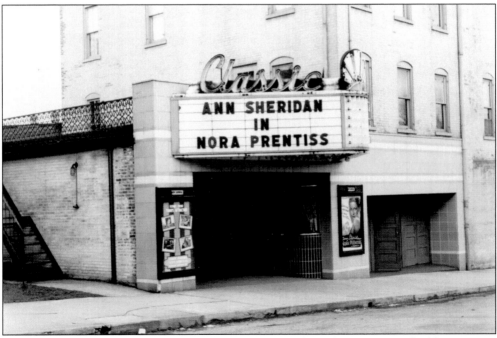

In the late 1930s, the M.E. Comerford Theater Company showed an interest in building a movie theater in Lehighton. At the same time, the Bayer family decided to invest in another theater. Rather than constructing a new building, they decided to renovate the old opera house on First and Iron Streets, which sat 499 people. The theater was called the Lehighton Classic Theater. It is shown here around 1941.

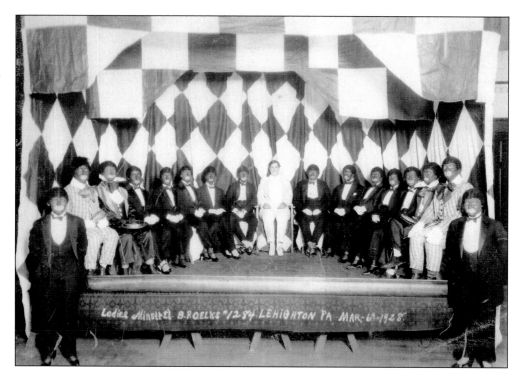

Throughout history, minstrels entertained the public with stories and song. Primarily musicians and actors, minstrels preferred to perform at places like county fairs. The minstrels pictured above were not the wandering kind, they were the Ladies of the Elks, Lehighton Lodge No. 1284, who held their first annual minstrel show on Tuesday evening, March 6, 1928. Below, the talented ladies are shown acting in a play. (Courtesy of Brad Haupt.)

Seven

THE SWIFT AND
THE MAJESTIC

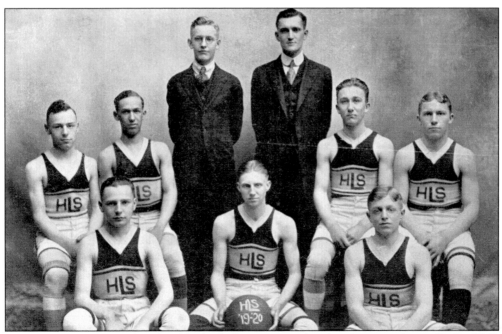

The first Lehighton High School basketball game was played in January 1914 in Butler Hall. The score was White Haven, 17, to Lehighton, 13. Teammates were Reichard, David, Gaumer, Christman, and Small. Coach Burt David is at right center in the second row. The following Saturday, Lehighton played Mauch Chunk at the YMCA. In Lehighton, games were played on the second floor of Lehigh Fire Company No. 2 until 1917, when they were played in the gymnasium of the new high school on Third Street.

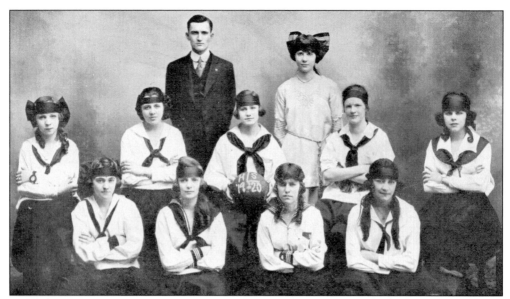

The *Lehighton Press* on November 10, 1916, noted that both the Lehighton boys and girls played Summit Hill in basketball at Engine Company No. 2 that week. Members of the girls' team were Mildred Obert, Louise and Anna Brinkman, Muriel Kaiser, Catherine Xander, Dorothy Roth, Josephine Heimbach, and Arline Kast. Burt David (pictured) coached the girls' 1919–1920 season. Shull-David Elementary School is named for him and Brinton Shull.

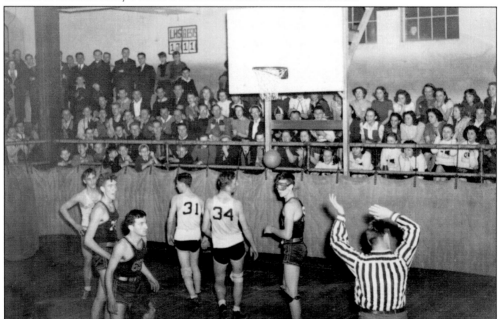

The former Lehighton High School gymnasium is pictured in 1939. One of the players is George Bibighaus, who later became principal of the school. Note the wooden backboard, the scoreboard in the upper left, the cheerleaders on the right, and the neat attire worn by the fans. In 2004, Pennsylvania governor Edward Rendell presented funds of $500,000 to the Redevelopment Authority of Carbon County for "the restoration of this building, which has been an anchor of the community for generations." (Courtesy of George Bibighaus collection.)

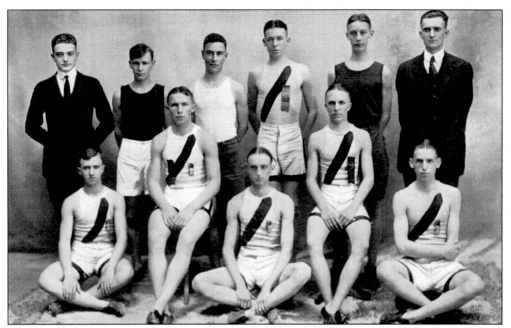

On June 16, 1922, Lehighton won the Carbon County track meet, the first of its kind in the history of the school. The Loving Cup the team won was displayed in the window at Wagner's drugstore. At that time, all racing events took place at the Lehighton Fairgrounds because the half-mile track was suitable for these activities. This track was used by the high school until the present fifth-of-a-mile track was constructed in 2011.

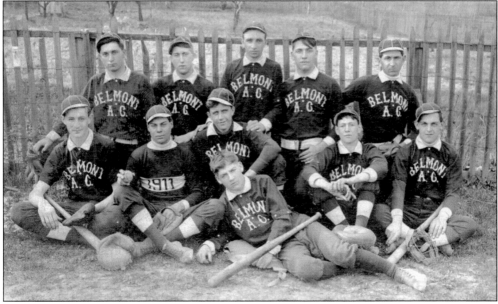

Shown is a rare photograph of the Belmonts baseball team of Jamestown in 1911. A local newspaper stated, "The Belmonts of Jamestown journeyed to White Haven yesterday and played two games with that strong team. The morning game was won by the Belmonts, 14 to 3, they took the strong White Haven boys by surprise and completely swamped them causing the umpire to call the game at the end of the seventh inning to prevent further slaughtering."

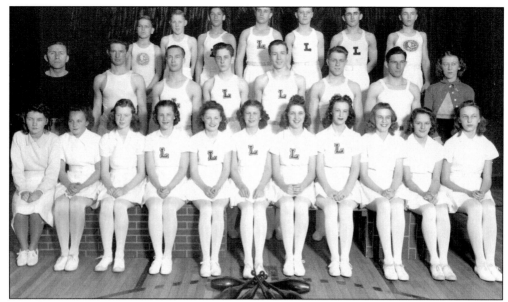

Lehighton won the annual physical education meet at East Stroudsburg State Teacher's College on April 13, 1940, for the eleventh time. Members were Doris Dreisbach, Vera Esrang, Shirley Fagan, Harold Frey, Janice Hartung, Geraldine Hill, Russ Jones, Bill Kirkendall, John Kobal, Jean Krum, Kathy Lauderburn, John Richards, Don Richards, Winifred Richmond, Donna Ricker, Claire Schaffer, Bill Sherman, Wayne Snyder, Mahlon Stout, Olive Wagner, and Betty Yost. Coaches were Miss Bock and Mr. Ginder.

This image is from the first season of Lehighton Knee-Hi Football in 1958. The players are, from left to right, (first row) D. Harleman (15), R. Longacre (19), P. David (18), R. Owens (12), J. Boyer (16), M. Christman (14), J. Wogenrich (13), D. Hall, and B. Remaley (11); (second row) P. Garret (21), R. Long (24), D. Seiwell (17), S. Zuker (10), B. Garret, B. Schaffer (22), E. Leffler (23), and R. Heiser; (third row) coaches Steve Tkach and Gerald Searfoss. The program is sponsored by the Lehighton Booster Club.

Pictured are the Lehighton Indians football players in 1912. The members are, from left to right, (first row) Clifford Miller and Edwin Harp; (second row) Exner, Arthur Mattern, William Frantz, Ralph Ronberger, Warren Rehrig, Daniel Koons, Norris Moskivitz, William Shoemaker, Stanley Ritter, and Charles Shutt; (third row) William Getz, Lesley Rex, Harry Xander, Harry Christman, Raymond Nothstein, Harry Metzger, Warren Kutz, Clarence Wagner, and coach "Chick" Townsend. Charles Shutt was the captain of the team. The Indians defeated Northampton 5-0 when Reed Bower plunged through the center to score. For many years, Charles Shutt was in charge of firing the cannon at Lehighton football games. Below is River Park, located on the "flats" across from the Lehigh Valley Railroad station around the 1920s. Today, Dunbar Beer and Soda Distributorship is on this property. A local paper reported that "Stroudsburg High School shaded Lehighton High School's Indians by a 6-0 score in a grueling struggle before several thousand spectators at River Front Park, Lehighton in their annual Turkey Day clash." (Courtesy of George Bibighaus collection.)

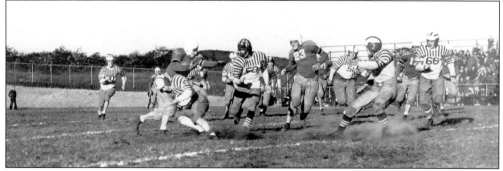

In his booklet "Scholastic Football in Pennsylvania's Lehigh Valley," published in 1982, Roger B. Saylor reported, "The first known contest between two area Pennsylvania public schools was Easton 18 and Allentown 0 in 1896." Depending on one's interpretation of "first known contest," Lehighton could have been the first because the *Carbon Advocate* newspaper of October 9, 1891, reported that the football season opened with Lehighton playing Slatington.

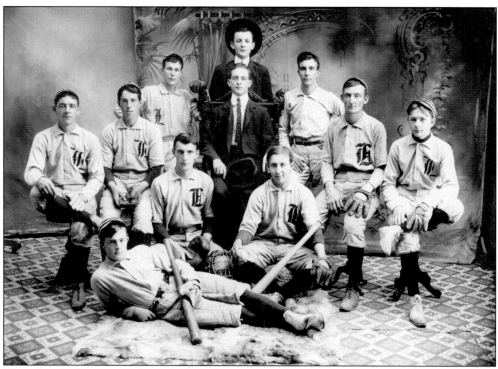

These baseball team members, the Regulars, pose in Bretney's studio in Lehighton. The 1906 season opened on May 11 with a street parade headed by the Lehighton and Liberty Bands, and the members of both teams participated. Mayor McCormick threw out the first ball. Twelve hundred fans attended the game; Lehighton defeated Lansford 8-3.

On July 23, 1897, 5,000 fans witnessed the Lehighton and Mauch Chunk game at the new fairgrounds in Lehighton. Frank Cannon and Ray Saul (the pitcher from Harrisburg) paraded around First Street that night with a street piano and passed around a hat until they were financially replenished, an annual fundraising ritual. (Courtesy of Brad Haupt.)

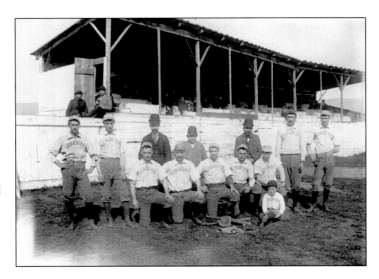

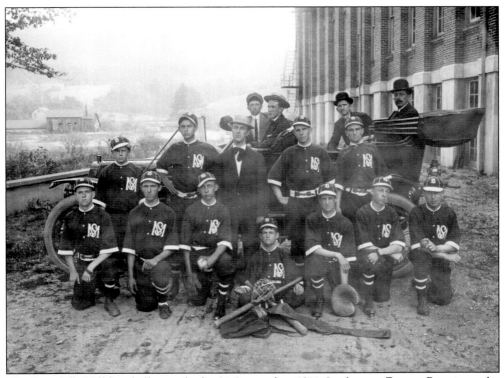

The Baer Silk Mill baseball team had a 24-8 record in 1911. In the car, Eugene Baer is on the right, and Charles Gilbert is on the left with chauffeur Bill Wertman. At center in front of the car is salesman Oscar Smith. Eugene W. Baer, a Lehighton businessman, contributed much to the community and was not just a baseball patron. In 1904, a new steamer pumper for Fire Company No. 2 was purchased through the efforts of Baer and James I. Blakeslee. (Courtesy of Carlos Teets.)

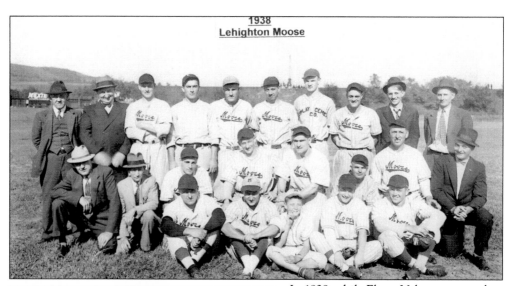

1938
Lehighton Moose

In 1938, while Elmer Valo was a member of the Lehighton Moose team, the team's director Edgar Paulsen arranged a meeting between Valo and Connie Mack's son Earl. Valo signed a contract to start playing after his graduation from Palmerton High School. He played 23 years in the major leagues for the Philadelphia Athletics, Kansas City Athletics, Philadelphia Phillies, Brooklyn Dodgers, Cleveland Indians, New York Yankees, Washington Senators, and Minnesota Twins. (Courtesy of Reuben Kunkle.)

On April 17, 1889, baseball great Hugh Jennings from Pittston, Pennsylvania, was brought to Lehighton to catch for fireball pitcher John Reichard by manager Clauss. In 1890, Jennings led Lehighton to the semi-pro championship of the Lehigh Valley. Two years later, he played for the Baltimore Orioles. In 1907, he managed the Detroit Tigers during Ty Cobb's years. In 1945, he was elected to the Baseball Hall of Fame.

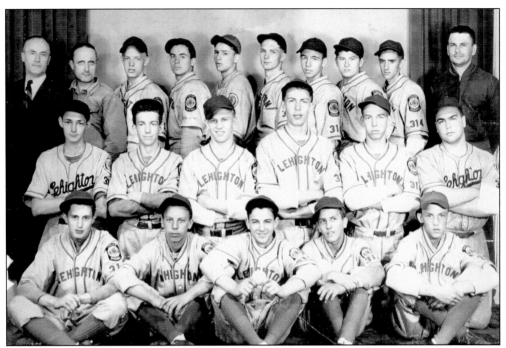

In 1946, the Tri-County Junior Legion Baseball League champions were, from left to right, (first row) Mel Everett, Richard Carrigan, Rueben Kunkle, George Zellers, and Norman Friend; second row) Richard Pennell, Phillip Paulson, Leidy Muffley, Alonzo Mantz, Dale David, and Floyd Rabuck; (third row) T. Hamlet Skip Hontz, head coach Jake Wolfersberger, Ted David, Robert Kipp, Horace Brobst, Jake Wolfersberger Jr., Donald Blauch, Clair Wentz, Jerry Arner, assistant coach Bill Gilham, and assistants Bill Christman and Joe Held, not shown.

On August 19, 1950, Lehighton won the Panther Valley League when they defeated Hauto, then Summit Hill in the finals. From left to right are (kneeling) Charles Yenser, Bobby Fisher, George Zellers, Russ Barry, Paul Goldbach, Bill Kunkle, Lee Kuntz, and Glen Warner; (standing) Dick Murphy, Dern Sharbaugh, Lenny Dietz, Kenneth Blauch, Moose Kunkle, Charles Stroup, Dale David, and Jack Finney. (Courtesy Reuben Kunkle.)

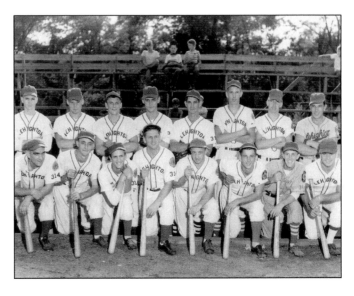

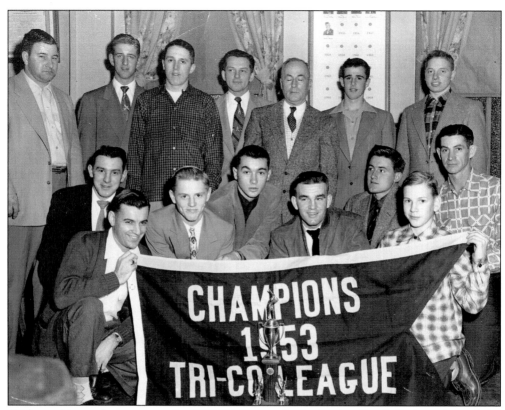

With trophies and a pennant, the 1953 Tri-County Junior Legion Baseball champions of the Lehighton American Legion team were Ronnie Costenbader, Larry Hill, Moose Kunkle, Bruce Kuntz, assistant manager and coach Dick Eckhart, Jack Ebbert, Bob Andrews, Legion representative Jackie Mullen, business manager Emmett Bock, T. Hamlet Skip Hontz, Jack Ashner, and Dave Jones. Holding the banner are scorekeeper and statistician Reuben Kunkle (left) and batboy Willard Andrews.

The *Times News* has covered news and sports in Lehighton for decades. In 1968, the paper moved into the old opera house of 1889 on First and Iron Streets with Nate Dermott as managing editor and Richard Benyo and Robert Parfitt as associate editors. Since its conception, its coverage of Carbon and Schuylkill County sports and news has been exemplary. The paper moved to a new building in Mahoning Township in 2003.

120

Eight

MAPS AND
MISCELLANEOUS

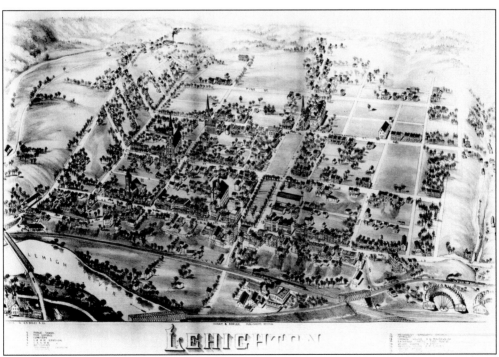

This map of Lehighton was published in 1883; it was lithographed and published by O.H. Bailey of Boston, Massachusetts. The key to the map lists the following highlights: public school, fairgrounds, cemetery, LVRR station, Lehigh and Susquehanna Station, Weissport, six churches, Carbon House, Exchange Hotel, Valley House, Mansion House, Lehigh Wagon, Central Carriage Works, Kuntz Brothers, and Gnaden Hutten Tannery. (Courtesy of Kenneth Seaboldt collection.)

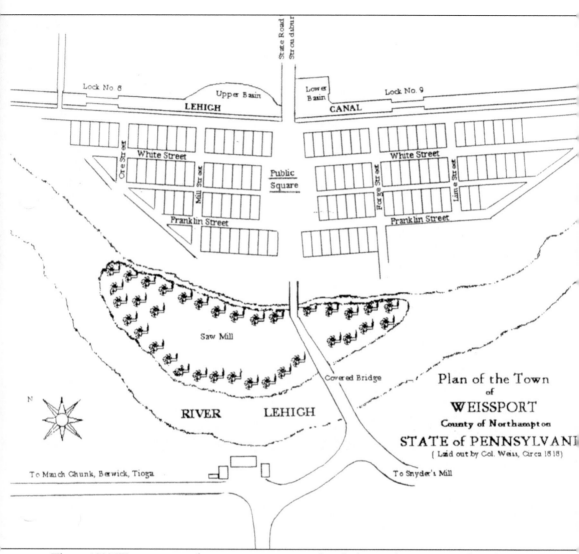

The following labels appear on the map:

State Road Stroudsburg

Lock No. 8 Upper Basin Lower Basin Lock No. 9

LEHIGH CANAL

Ore Street White Street White Street

Mill Street Public Square Forge Street Lime Street

Franklin Street Franklin Street

Saw Mill

Covered Bridge

N

RIVER LEHIGH

Plan of the Town
of
WEISSPORT
County of Northampton
STATE of PENNSYLVANI
(Laid out by Col. Weiss, Circa 1818)

To Mauch Chunk, Berwick, Tioga To Snyder's Mill

This c. 1889 Weissport map shows many interesting details that are long gone, such as the Yeakel & Albright Saw Mill, various buildings along the Lehigh Canal, and Public Square Park. The map even lists the names of the homeowners on all the streets.

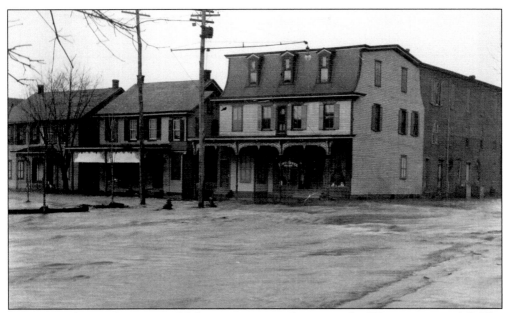

The floods of December 1901 and February 1902 were the worst to hit Weissport since 1862. The December 1901 flood damaged the LVRR, washing away the track. The damage in Weissport and Lehighton from December was compounded when the February 1902 storm struck. Rain began falling in the morning of February 28 and continued all day. Heavy snow the week before brought runoff into the Lehigh River. (Courtesy of Robert Fatzinger.)

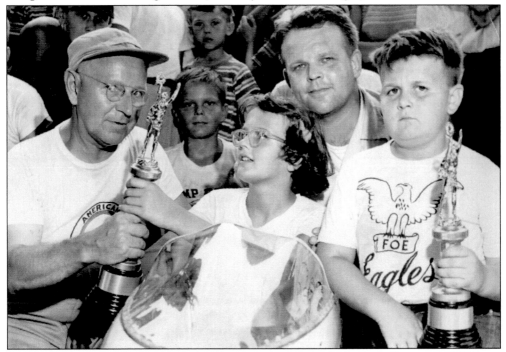

Following the lead of John Kutz, who managed the great Lehighton baseball team of 1887, James Whitehead (left) promoted youth baseball in Lehighton in the 1950s and is remembered for his enthusiasm and dedication.

On July 10, 1962, the Lehighton borough council approved contracts for the new swimming pool at Baer Memorial Park. The total cost was $179,180. The accepted bids included: general contractor, H.E. Stoudt, Allentown, $99,850; plumbing, J.L. Turner, Nanticoke, $63,865; and electric, Larry Stoudt, Lehighton, $15,465. After an almost 50-year run, this popular spot needed extensive repairs and faced closure, but thanks to the Lehighton Pool Pals, it is repaired and thriving.

In May 1927, Graver Bathing Casino opened for the first time. This was the largest concrete pool in Pennsylvania. The casino was equipped with roomy lockers, water ponies, great slides, and diving boards. Later that season, floodlights were installed for night bathing. The pool was open from 10:30 a.m. to 10:30 p.m. The pool manager was Ralph Graver. (Courtesy of Robert Fatzinger.)

On January 20, 1950, the Bank of Lehighton was opened in the former Dime Bank building after the building was given a complete face-lift. Officers of the Bank of Lehighton in 1953 were Pres. John Adams and Vice Pres. Gordon Bennett, who was later elected president. The board of directors included Harry Barson, Gordon Bennett, John Adams, Bronne Bruzgo, Donald Eckman, William Richards, and Joseph Humphries. In 1969, the Lehighton Bank merged with Peoples First National Bank & Trust, with Bennett as vice president.

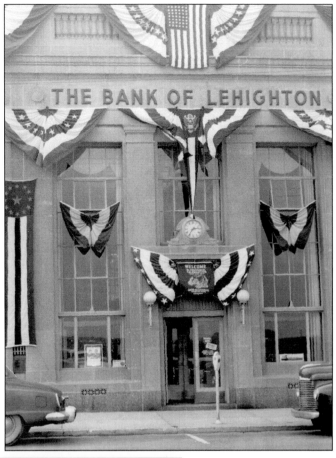

Dr. Sylvester F. Lentz was born in Nanticoke, Pennsylvania, in 1903 and graduated from Penn State University in 1926. He received his medical degree from Jefferson Medical School in 1930, interning at York General Hospital in 1932. Dr. Lentz purchased the home and office of the late Dr. David Dreisbelbeis at the corner of Third and Mahoning Streets, where he resided with his family. He served in the US Navy during World War II and was the school doctor for the Lehighton School District for many years.

When the flag was lowered at Camp Chickawaki in the summer of 1968, the camp closed for the last time after 25 years. This was a day camp for boys that was owned and operated by Mr. and Mrs. Lewis A. Ginder. Fond memories of Camp Chickawaki remain with many of "Uncle Lewie" and "Aunt Ding." Educator, athletic coach, and civic leader Lewis A. Ginder was truly a superstar.

These Lehighton boys went to Amherst, Massachusetts, in the summer of 1948 to pick tobacco. Those participating were Maynard Andrew, John Rakos, Bob Hammel, Hayden Snyder, Richard Ockenhouse, Richard Stein, Eugene Hinkle, Joseph DeSousa, Carmen Martucci, Ethel Futon, Ana Rhoades, Richard Klotz, Bruce Begel, Clarence Hoffman, William Klotz, Nickolaw Tdojo, Edward Andrews, Dale Klotz, Robert Billman, Charles Gernerd, Lee Wentz, Fred H. Biege, Ralph Fritz, Charles Benner, Art Richmond, Bill Ruch, and Al Domenico.

Lehighton businessman Kenneth Seaboldt and Charles Schick clown around in front of Schick's Men's Store on First Street in 1952. Seaboldt is in the wheelbarrow wearing an "Ike" campaign pin. There are campaign posters for Dwight D. Eisenhower and Richard Nixon on the door of Schick's shop as well. Seaboldt was an insurance agent in Lehighton for many years. (Courtesy of Kenneth Seaboldt collection.)

This Mahoning Valley gas station was owned by one of the Hammel brothers of Lehighton. Located in Mahoning Valley across from what is now Mahoning Elementary School, the original small building is still at the same spot. The antique gas pumps unfortunately are gone and so is the sign. (Courtesy of Lyle Stern.)

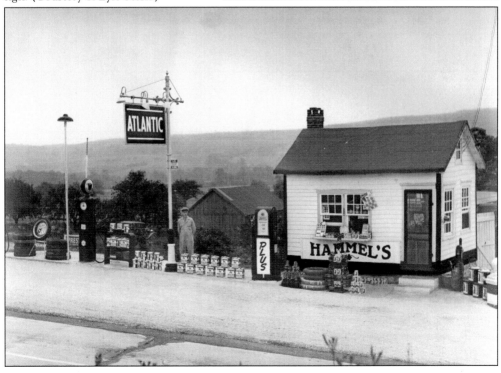

DISCOVER THOUSANDS OF LOCAL HISTORY BOOKS FEATURING MILLIONS OF VINTAGE IMAGES

Arcadia Publishing, the leading local history publisher in the United States, is committed to making history accessible and meaningful through publishing books that celebrate and preserve the heritage of America's people and places.

Find more books like this at
www.arcadiapublishing.com

Search for your hometown history, your old stomping grounds, and even your favorite sports team.